Bernd Growe

Edgar Degas
1834–1917

Benedikt Taschen

FRONT COVER:
Café Concert Singer (detail), 1878
Chanteuse de Café-Concert
Pastel (mixed media) on canvas, 52.8 x 41.1 cm
Cambridge (MA), by kind permission of
The Fogg Art Museum, Harvard University,
Bequest of the Maurice Wertheim Collection, Class of 1906

PAGE 2:
Dance Class, 1874
La Classe de danse
Oil on canvas, 85 x 75 cm
Paris, Musée d'Orsay

BACK COVER:
Edgar Degas, about 1855–60

This book was printed on 100 % chlorine-free bleached
paper in accordance with the TCF standard.

© 1994 Benedikt Taschen Verlag GmbH
Hohenzollernring 53, D-50672 Köln
English translation: Michael Hulse, Cologne
Cover design: Angelika Muthesius, Cologne
Composition: Utesch Satztechnik GmbH, Hamburg
Printed by Druckhaus Cramer GmbH, Greven

Printed in Germany
ISBN 3–8228–0560–2
GB

Contents

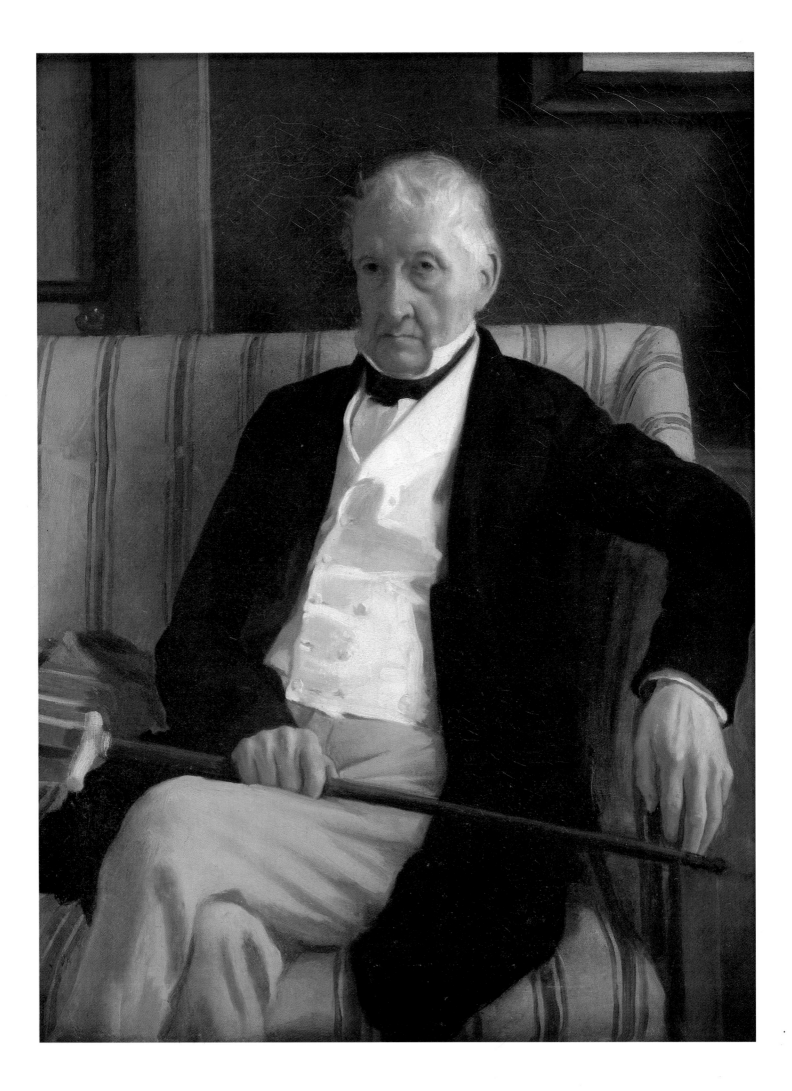

FMP : DIARY 2011

Date	Notes
28/03/11	
4/04/11	
11/04/11 e	
18/04/11 e	
26/04/11	
03/05/11	
09/05/11	
16/05/11	
23/05/11	
30/05/11 sp	
06/06/11	
13/06/11	Exhibition.
20/06/11	

Wonderful Years

Degas's background and beginnings would scarcely suggest he was predestined to be the revolutionary he was, so comprehensively reconceiving our visual perceptions. He was born in the Rue Saint-Georges, Paris, on 19 July 1834. His father, Auguste de Gas, was a banker, and ran a branch of a Neapolitan bank owned by the family. A temperamental man, Degas was always to be Mediterranean in nature. His mother died in 1847, so the boy's father and grandfather were the most influential figures in his early life. Even in hard times, Degas's social position assured him freedom from the material worries which all too often plagued his fellow artists.

The present study is neither a biography of Edgar Degas nor a history of his art, nor an attempt to explain the one by means of the other. I shall be trying to describe the phenomenon or entity we mean when we say "Degas"; the identification of biographical or historical roots will not be my concern. The style of art monograph evolved by Vasari in the 16th century has largely remained the norm down to the present day: an account of the artist's background and youth is followed by a descriptive list of the works and then an overall appraisal of the artist's personality and achievement. In an age which no longer views the interrelations of creator and creation in terms of a single, unified self, we cannot altogether subscribe to this norm. Thumbnail biography and close analysis of particular works will therefore alternate in what follows.

The present study aims to convey the expressive richness, the scope, and the experimental diversity of Degas's art. Those who approach his art via specific avenues of enquiry – his preference for particular subjects, his artistic methods – will soon realise that his range is far broader than a handful of popular works might suggest. No single approach can do justice to an artist of such diversity, affected by Realism and Impressionism alike, familiar with the major aesthetic movements of his time, yet still independent, pursuing his own ideas. Both in his art and as a private person, Degas was an uncompromising man,

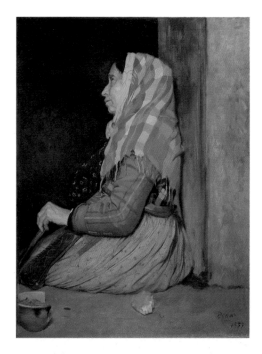

Roman Beggar Woman, 1857
Mendiante romaine
Oil on canvas, 100.3 x 75.2 cm
Birmingham, Museum and Art Gallery

Hilaire de Gas, 1857
Oil on canvas, 53 x 41 cm
Paris, Musée d'Orsay

and this too confirmed him in his independence and made him
something of an outsider.

From 1845 to 1853 Degas attended the Lycée Louis-le-
Grand, a well-thought-of school where he rapidly acquired a
name for his skill at drawing. There he made friendships that
were to last a lifetime with Paul Valpinçon, Henri Rouart and
Ludovic Halévy. Despite his own wish to paint, he began to
study law, but broke off his studies in 1853. He frequented
Félix Joseph Barrias's studio and spent his time copying Re-
naissance works; all those Sunday visits to the Louvre with his
father, and his familiarity with the art collections of family
friends, were paying dividends now. One of these collectors,
Prince Grégoire Soutzo, played an important part in Degas's
choice of vocation, as did his father's remarkably understanding
attitude and advice: the atmosphere in which Degas's decisions
were taken was a favourable one. Barrias soon referred Degas
to Louis Lamothe, whose studio Degas joined a year later, to re-
ceive proper technical training.

In 1855 he met Ingres and warily admitted that he wanted
to be an artist. Ingres advised: "Draw lines . . . a lot of lines,
whether they're from memory or from Nature." His words be-
came the young Degas's gospel. At the Paris World Fair in the
same year he had ample opportunity to study the work of Dela-
croix and Ingres in major retrospective shows.

At that time Degas began to keep a journal. Along with re-
cords of theatre visits, and analysis of his own character, it con-
tained his first attempts to formulate artistic principles. His
choice of early heroes betrays Degas's characteristic reconcilia-
tion of tradition and the new. It was a tension that informed his
response to Impressionism and deeply affected his adoption of
modern subjects. "Ah, Giotto!" he wrote, "let me see Paris.
And, Paris, let me see Giotto!"

In 1856 Degas travelled to Italy, where he had the chance to
see Giotto. First he stayed in Naples, at the Palazzo Pignatelli
di Monte Leone, with grandfather René Hilaire de Gas, uncles
Henri Edouard and Achille, and aunts Rosa Adelaide Morbilli
and Stefanina. It was not so much for its picturesqueness that
Naples impressed Degas, but rather as a city where the arts
throve. He went to the opera and studied the old masters, in-
cluding landscape drawings by Claude Lorrain. He drew por-
traits, bearing in mind his father's urgent advice to concentrate
on portraiture. Later, in painting grandfather Hilaire (p. 6), this
preparatory work assisted him greatly. The eighty-seven-year-
old is seen sitting on a sofa, relaxed, his ivory-handled cane in
his lap. Degas has been frank about the stern presence of the
old man: that cane is a discreet but definite reminder of the
calm authority of the head of the family.

The following year he moved on to Rome, where he met a
number of acquaintances, among them Léon Bonnat, another
former student of Lamothe's. He made new friends such as

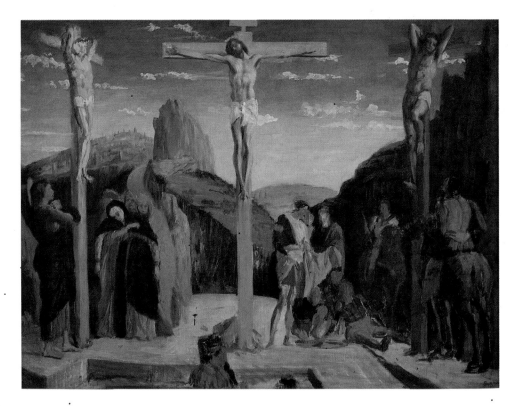

Copy of Mantegna's Crucifixion, 1861
Le Calvaire (copie d'après Mantegna)
Oil on canvas, 69 x 92.5 cm
Tours, Musée des Beaux-Arts

Georges Bizet and (a close friendship) Gustave Moreau, who were to be found in the Académie Française circles at the Villa Medici, run by Victor Schnetz. (Those such as Degas who did not have an academy stipend were allowed to work there too.) The *Roman Beggar Woman* (p. 7), which Degas was much later to date to the year 1857, was a type of picture Victor Schnetz had long been advocating. Schnetz felt that scenes of everyday life in Italy offered a way of avoiding the dangers of too crude a realism. Degas's picture shows the old woman in profile in a doorway, with her meagre rations; the artist draws our attention via the folds in her clothing and her checked headscarf to the woman's facial features, set off against the darkness of the doorway.

In Rome, together with his new friend Moreau, Degas visited the art galleries. The formidable cornucopia of art afforded him a bountiful harvest, and he filled no fewer than twenty-eight sketchbooks.

In summer 1858 he travelled via Viterbo, Orvieto, Perugia, Assisi and Arezzo to Florence. The Italian landscape and light fascinated him; nonetheless, Degas was already quite clearly wary of taking the natural world as a subject for his art. This early mistrust, or lack of interest, was later to become a regular aversion. Giotto's frescoes at Assisi, however, excited him greatly – and he even refused to draw them on the grounds that he wanted to retain the first impression for ever.

By 1860 Degas had drawn over seven hundred copies of other works, mainly early Italian Renaissance and French classical art. What interested Degas was movement, and arabesques; so he tended to view individual figures in isolation from their

"I am quickly bored if I look at Nature. I have no desire at all to draw from Nature."
EDGAR DEGAS

visual contexts, for reasons of his own rather than in obedience to the principles of art history. This exploration of physical shapes and gestures provided him with a repertoire which he could always fall back on whenever the need arose.

Degas was registered as a copyist at the Louvre in Paris as early as 1853. There, he pressed ahead with his artistic training in a spirit idiosyncratically his own: "One must copy the masters again and again . . ." The paintings he copied were more than objects of research to him: "The air we see in the pictures of the old masters is not an air that can be breathed!" Degas claimed to have copied all the old masters in the Louvre. Among the works was Mantegna's *Crucifixion*, the centre predella panel of the 1458 altar piece done for San Zeno in Verona, which Napoleon had carried off to Paris in the course of his Italian campaign. Quite probably the copy (cf. p. 9) was not done till 1861. It is not an exact reproduction of the original; rather, it is a rare attempt on Degas's part to capture the special atmosphere of the work in silhouettes and strong colours, in a mood beyond the dry linearity of Mantegna. Mantegna became a touchstone to Degas. "The frame of a painting by Mantegna contains the world, whereas the moderns are only capable of rendering a tiny corner of it, a mere moment, a fragment."

It was at the invitation of Baron Gennaro Bellelli and his wife Laura (an Italian aunt) that Degas went to Florence in August 1858. There he did numerous drawings of the family. It was not till March 1859 that he returned to Paris – where, in his Rue Madame studio, he finally painted his group portrait *The Bellelli Family* (p. 11), which he had planned in Florence and had indeed already re-thought repeatedly. It originated in a planned double portrait of his cousins Laura and Giulia (in November 1857); later, the mother and then the baron were also included in the composition.

The Bellelli Family is an extraordinarily ambitious work. It records psychological tensions with immense precision, tensions which undermine the social poise and pose of the sitters. Degas combines imposing presence with domesticity. The painting has been interpreted as rendering the different ages of human kind by showing us various generations and indeed including the unborn and the dead: the baroness was pregnant at the time, while on the wall behind her we see a red chalk drawing of her father, René Hilaire de Gas, who had died in 1858. But social standing and domesticity are not the real subject of the painting, as we will realise if we take a closer look. What looks like unruffled family life turns out to reveal a psychological contrast through Degas's inclusion of the baron.

The baron is seated with his back to us at the right-hand edge of the composition, and has no real presence to counterbalance the group of mother and daughters. As a sketch shows, Degas originally positioned the father in a frontal posture at the end of the table; but in the final version he has been margin-

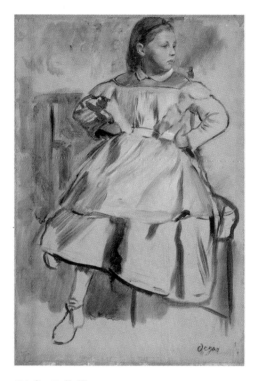

Giulia Bellelli, 1858
Oil on paper, mounted on canvas,
38.5 x 26.7 cm
Washington, D. C., Dumbarton Oaks
Research Library and Collections

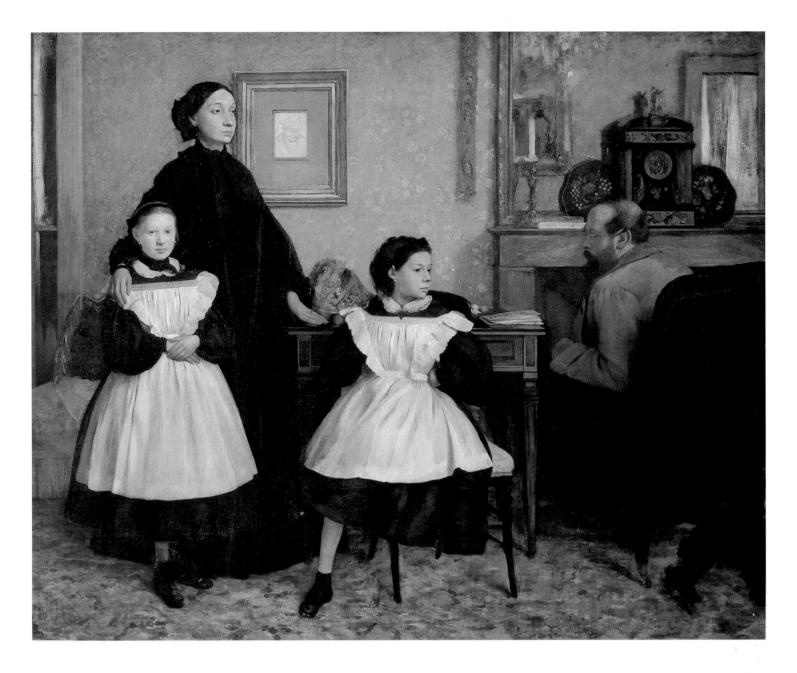

The Bellelli Family, 1858–67
La famille Bellelli
Oil on canvas, 200 x 250 cm
Paris, Musée d'Orsay

alized, removed from the family centre. The mother and wife is the focus of attention. She was twenty-eight when she married Gennaro Bellelli, a lawyer and liberal journalist; the marriage was probably an arranged one. The picture lays bare the frustrations of that marriage by highlighting the distance between the father and the female members of the family.

Degas has given special attention to Giulia. Though her bodily posture allies her with her mother, she is looking sideways towards her father. Her left leg under her, hands nonchalantly on her hips, she constitutes an untroubled midway point between the tensed poles of her parents. Capturing the moment in this way enables Degas to convey a sense of immediate presence; the sheer relaxation of Giulia's pose (which Degas attained through a series of studies) marks off this family portrait from the prevailing conventions of the time. (Degas was later to

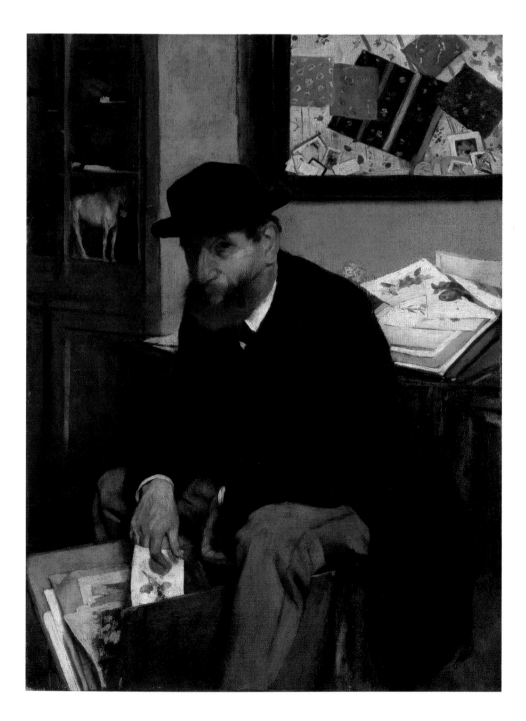

The Collector, 1866
L'Amateur d'estampes
Oil on canvas, 53 x 40 cm
New York, The Metropolitan Museum of
Art, Mrs. H.O. Havemeyer Bequest, 1929,
H.O. Havemeyer Collection (29.100.44)

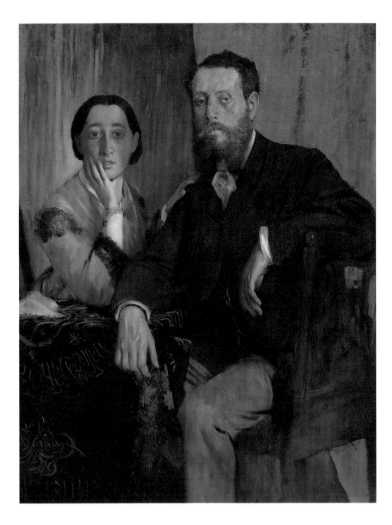

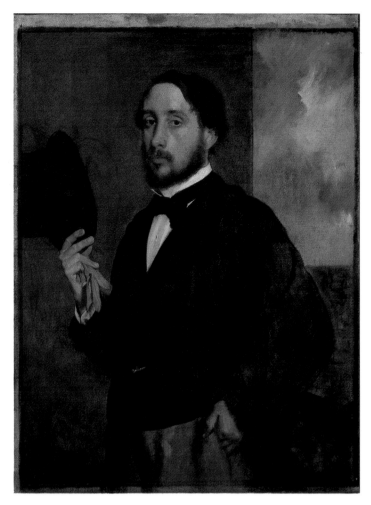

do further portrait work involving the point at which a pose can be defined as a temporary posture.) Without carcicaturing, but equally without covering anything up, *The Bellelli Family* uses the unmet and unanswered gaze of the marital partners to analyze irreconcilable differences in their inner lives. It also contrasts the generations, now unbound by formal, conventional ideals. But, more than this, in the evasion of contact there is also an implied confrontation with us, looking on, to whom the onus of evaluation and commentary is left. In a sense, the painting was Degas's manifesto. It not only documented his aim "to create a family portrait . . . in the undaunted spirit of the 'ronde de nuit'"; it also indicated the ways his work would evolve. For the first time we see the artist exploring the isolation of the individual, a subject which Degas was to examine in every walk of society.

The visit to Italy had roused his ambition. Degas returned to Paris with great plans and strengthened self-confidence. To his friend Valernes he later remarked that that period was the most wonderful in his entire life. The unfinished self-portrait of 1863 (p. 13) shows a man not quite thirty, a stylish man of the middle classes, with gloves and top hat, facing whatever the future may have in store with calm self-assurance.

ABOVE LEFT:
Monsieur and Madame Edmondo Morbilli,
about 1865
Monsieur et Madame Edmondo Morbilli
Oil on canvas, 116.5 x 88.3 cm
Boston, The Museum of Fine Arts, Gift of
Robert Treat Paine II, 1931

ABOVE RIGHT:
Self-portrait, about 1863
Portrait de l'artiste
Oil on canvas, 92.5 x 66.5 cm
Lisbon, Museu Calouste Gulbenkian

PAGES 14/15:
Hortense Valpinçon, 1871
Mlle Hortense Valpinçon, Enfant
Oil on canvas, 76 x 110.8 cm
Minneapolis, The Minneapolis Institute of
Arts, John R. Van Derlip Fund

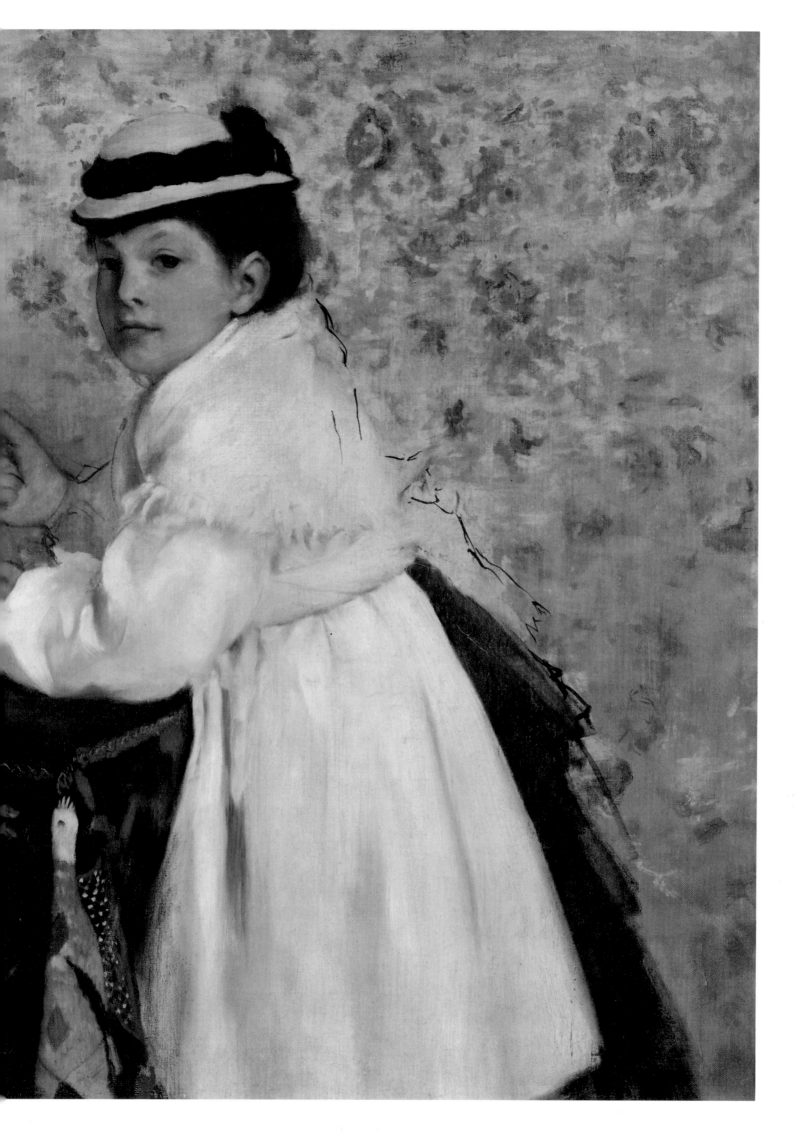

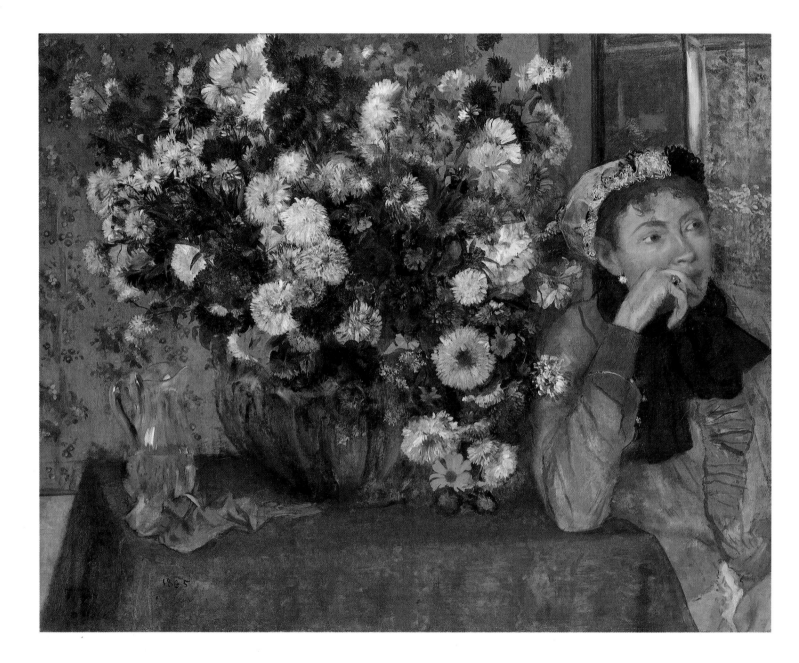

Historical and Portrait Paintings

Now that French 19th century art is no longer viewed in the simplistic terms of salon art versus avant-garde art, historical painting has been evaluated afresh. This process has also affected our interpretation of early Degas. For Degas, despite the waning importance of grand historical art in the post-classical period, was not without his aspirations to satisfy aesthetic doctrines and the prevailing taste of the time by producing historical paintings.

From 1855 to 1865, Degas was occupied with a number of such works, some of them large-format. His models were Jean Auguste Dominique Ingres, who had emphasized the significance of history, and Eugène Delacroix; among his contemporaries, Degas also valued Puvis de Chavannes. Many of his projects never left the planning stage, or remained unfinished. It was an early indication of Degas's aversion to the completed artefact. His historical works all betray a hint of doubt as to the relevance of what he was doing. In his treatment, they became a place to approach the conflict between genre requirements and the artist's current interests. It is a conflict which we might describe as the polarity of history and authenticity.

The most important work of this period was *Spartan Girls Challenging Boys*, painted in 1860–62 (p. 20). Degas did no fewer than sixteen drawings and two oil sketches by way of preparation. For Degas, thinking up the subject and presenting it in a particular way were in themselves acts of history. It is typical of his history paintings, indeed of his procedure in general, that the work was not done spontaneously but as a careful process of construction, even of assemblage. The painting's source may have been a passage in Plutarch concerning competitive rituals in ancient Sparta. Degas's presentation of the boys and girls, their strutting and their reactions, may perhaps be seen as a projection of the artist's own longings and fears – which might make it easier to understand why he exhibited it as late as the fifth Impressionist show in 1879, and kept it in his studio throughout his life.

Study of Madame Valpinçon, 1865
Etude pour femme accoudée prés d'un vase de fleurs (Mme Valpinçon)
Pencil on white paper, 35.5 x 23.4 cm
Cambridge (MA), by kind permission of
The Fogg Art Museum, Harvard University,
Meta and Paul J. Sachs Bequest

Woman with Chrysanthemums, 1865
La Femme aux chrysanthèmes
Oil on canvas, 73.7 x 92.7 cm
New York, The Metropolitan Museum of
Art, Mrs. H.O. Havemeyer Bequest, 1929,
H.O. Havemeyer Collection (29.100.128)

Spartan Girl, about 1860
Jeune fille spartiate
Pencil on paper, 22.9 x 36 cm
Paris, Musée d'Orsay

The rivalling youngsters strike us as Parisian rather than Spartan. The girls are aggressive and provocative; the boys are seen responding to the challenge. The closed group of girls are dominant; the boys are grouped more loosely, and behave as individuals. Just as the recoil of the boys responds to the forward movement of the girls, the entire choreography of move and counter-move produces a complex interaction of gestural to and fro, polarities and couplings indicative of choice and consent. The scene records the moment when a game begins to be meant seriously.

Degas's staggering composition (the first girl's outstretched hand is precisely in the centre of the painting) links the jerky and spontaneous movements of the moment into a well-conceived spatial entity.

This picture of young Spartans strikes us as true to life. And yet, it remains an attempt to render the historical painting relevant by the use of inappropriate means. The ancient subject and the up-to-date naturalism are strictly at odds – and contemporary critics were not slow to ridicule the resulting conceptual fracture: in place of the idealized figures expected in a historical painting, they said, Degas had offered the unattractive reality of "skinny suburban brats".

It was with a historical painting that Degas made his Salon debut in 1865. *The Sufferings of the City of New Orleans* (p. 21), to the artist's disappointment, was given scant attention. The reason was perhaps that Manet's *Olympia*, also selected by a liberal-minded jury, was monopolizing critical controversy. Degas's work must have seemed anachronistic and artificial; a mediaeval landscape setting, of all things, was being used to symbolize the sufferings of the American city of New Orleans, which was occupied by Union troops in 1862 in the course of the Civil War. Despite the burning city in the background, and

Reclining Woman, 1865
Femme demi-nue, allongée sur le dos
Pencil, 22.8 x 35.6 cm
Paris, Musée d'Orsay

the contrast of soldiers and helpless victims, there is no real dramatic tension in the painting. The figures make a scattered impression – particularly the prostrate female nudes, to whom Degas (as his preliminary drawings show) had devoted careful attention. He has put them in poses that emphasize the torment they are undergoing; but the more expressive their bodies are, the more they seem nudes independent of the action of the picture. Degas has also squeezed the action out to the margins of the scene, leaving an empty central section and a badly cropped figure (the rider at right, carrying off a nude figure). For the sake of these visual effects, Degas has dispensed with a coherent narrative statement. *The Sufferings of the City of New Orleans* turned out to be his last historical painting.

The years from 1852 to 1865 were crucial to the subsequent evolution of Degas's work. After 1862 Degas gradually took his bearings anew, via history and portrait painting. He had to decide whether to go on applying traditional approaches to new subjects or to locate his own alternatives. Ways of seeing that were schooled on the conventions of historical art could only confront the issue of authentic experience in a spirit of opposition. And so Degas's history paintings attest the emptiness and theatricality of the genre: history as a spectacle that has little to do with what may really have happened.

Spartan Girls Challenging Boys was an attempt to locate contemporary affairs in history. But the great tradition of history, which Baudelaire had identified as lost in 1846, could no longer be re-established by *grande peinture*. The dividing line between history and genre had vanished. In mid-century, interest in historical art began to flag noticeably, because private collectors who commissioned works had quite different preferences. One critic, Castagnary, observed: "Little by little, religious and historical or heroic art has been relegated to the same

level as theocracy and monarchy. The social structures that supported it have become extinct." If history is increasingly seen as a reconstructable process, historical content can no longer be imposed upon the present as a norm. The irreconcilability of contemporary experience and history leads to a shift in perception, too: what now became of greatest importance was not scrutiny of heroes and their deeds but the situation of the onlooker.

Degas redoubled his efforts in portrait painting. In 1865 he painted *Monsieur and Madame Edmondo Morbilli* (p. 13), one of a number of double portraits for which Degas may have been inspired by daguerrotypes. It was in portraits that seemed most obviously to abide by handed-down conventions that Degas was best able to establish his own distance from the genre.

Seated before a neutral background, the Morbillis are presented with all the characteristic psychological verve of our artist. The duke, though the dominant partner, is slightly displaced from the centre, which creates spatial tension between the two sitters. Their characters begin to seem as different as the colours of the backgrounds they are seen against. Relaxed as

Spartan Girls Challenging Boys,
about 1860–62
Petites filles spartiates provoquant des garçons
Oil on canvas, 109 x 155 cm
London, The National Gallery

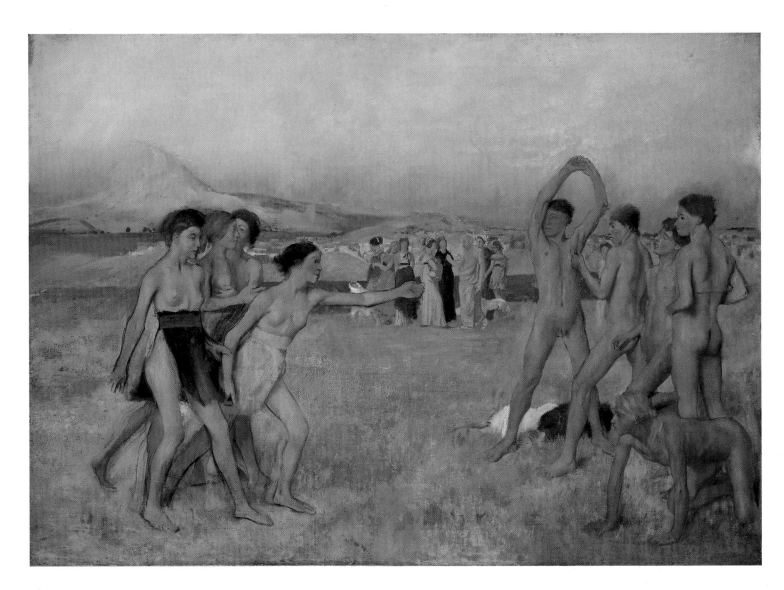

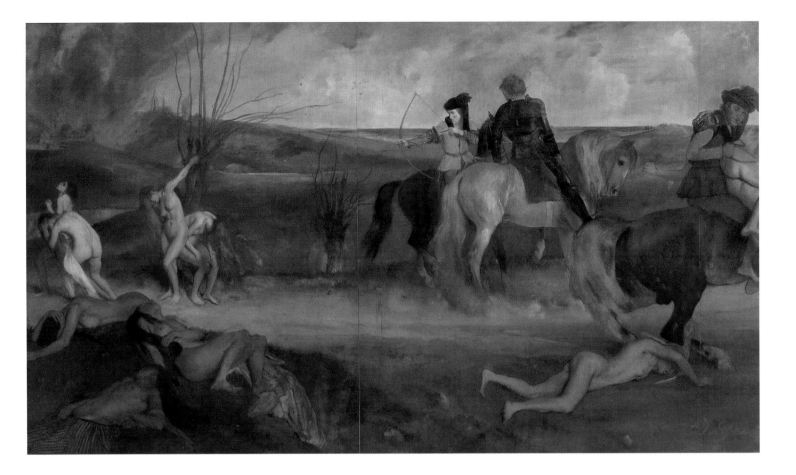

his posture may be, the duke is clearly a man of aristocratic reserve; and the duchess's gently melancholy air provides a contrast. The character difference between the two emerges not through any action or compositional dichotomy in the painting but through our own perception as we look at it. The gentleness of Thérèse's body language serves as a kind of commentary on the passivity visible in Edmondo's hands. Her own left hand is resting on her husband's shoulder while the fingers of her right lie thoughtfully against her cheek, as if she were momentarily turning from her husband and towards us. The shadow of the man falls across her earnest features.

In *Woman with Chrysanthemums* (p. 16), painted in the same year, Degas's takes a different approach: the chrysanthemums and the woman (squeezed almost out of the picture by the flowers) rival each other in their claims on our attention. The woman may be Madame Valpinçon. We are inclined, by the force of convention, to see the human figure as the centre of the composition; but the position Degas has put her in is at odds with this. He has indeed further teased our sense of the true subject by showing her with face partly hidden by her hand. The asymmetrical, *ex*-centric composition serves purposes of immediacy and impact; but it does so at the expense of the sitter. The egalitarian treatment of the woman and the flowers also gives Degas an opportunity to compare the chrysanthemums' physical presence and the mental absence of the woman, lost in a day-dream. The scene is a simple glimpse of

The Sufferings of the City of New Orleans,
1865
Scène de guerre au moyen âge, dit à tort:
Les malheurs de la ville d'Orléans
Oil on paper, mounted on canvas,
81 x 147 cm
Paris, Musée d'Orsay

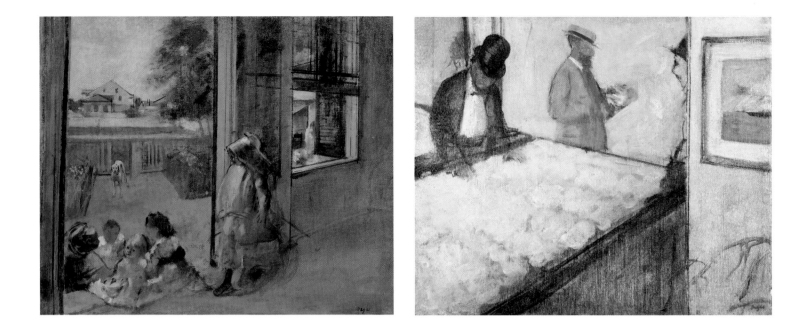

everyday life; in this respect, Theodore Duret (in his commentary on the 1870 Salon) put his finger on the heart of the matter when he observed that Degas was always primarily interested in a "distinctive type" and that the Parisian type (say) counted for more with him than individual qualities. Degas – as Duranty foretold at the time – was well on his way to becoming a "painter of the upper ten thousand". His portraits were documents recording the impossibility of capturing any authentic individuality in the changed circumstances of modern life.

During the Franco-Prussian War of 1870, Degas volunteered for the infantry. In marksmanship training his eye trouble became apparent for the first time. Degas was under the command of his old fellow-student Henri Rouart, who was still a good friend. For the duration of the Commune he left Paris and joined the Valpinçons at Ménil-Hubert. There he painted the almost impressionist portrait of the nine-year-old Hortense Valpinçon (pp. 14–15), with whom he was to remain in touch in later years. The asymmetry of the composition is comparable with that of *Woman with Chrsyanthemums.* The table and embroidery are seen at an angle, and the girl is well to the right of centre, looking up from the piece of apple in her hand across to the painter. All of this, together with the unconstrained style in which the wallpaper has been painted, gives the work a vividly dynamic quality which we may well interpret as expressing the child's natural restlessness.

It was in the troubled post-war years that Degas undertook his longest journey. In 1872, with his younger brother René, he travelled via London to New York and New Orleans, where his uncle Michel Musson ran a cotton business. Degas stayed in Louisiana for five months and did not return to Paris till February 1873.

He was excited by America's technological progress – such

as the railway sleeping cars – but he sorely missed the cultural and social life of Paris: "The lack of the opera is a real torment to me." Performances in private homes such as the one that prompted the 1872/73 *Song Rehearsal* (p. 27) could not afford any substitute. The picture's subject is not the music on offer but the activity of rehearsal. The perspective and gestures highlight the duet relation of the two singers. Even the pianist is depicted in the act of turning, and Degas goes so far as to emphasize the movement of his head through the contrast with the hard-line precision of the door.

Courtyard of a House in New Orleans (p. 22) shows part of the Musson home in Esplanade Avenue and possibly the room that served Degas as a studio during his stay. Little Carrie Bell is in the doorway with her hoop, and other children are on the step with the nanny. Of all the paintings Degas did in America, this one best conveys a sense of the distinctive New Orleans atmosphere and light.

"One must not create Paris art and Louisiana art without any distinction. It would become a 'monde illustré.'"
EDGAR DEGAS

Portraits in a New Orleans Cotton Office,
1873
Portraits dans un bureau (Nouvelle-Orléans)
Oil on canvas, 73 x 92 cm
Pau, Musée des Beaux-Arts

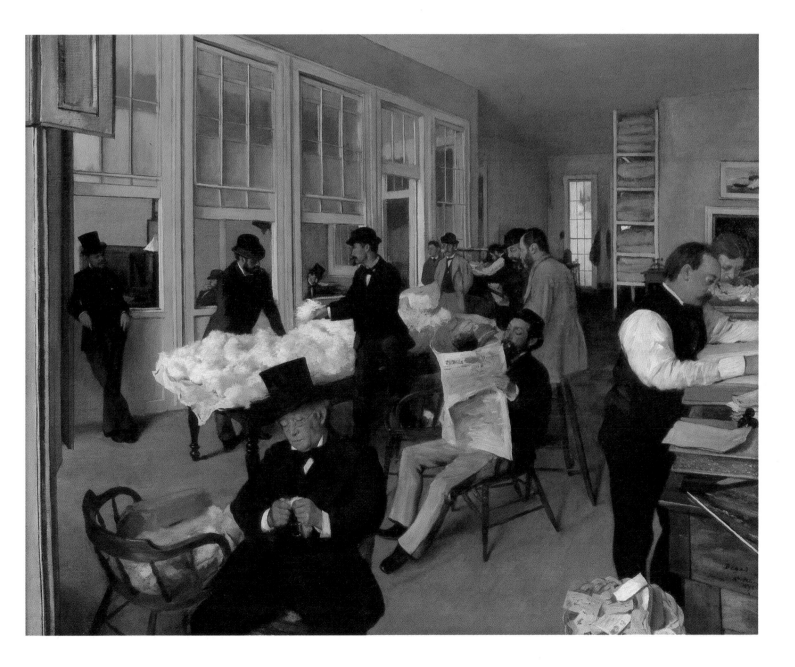

The Pedicurist (p. 26) is another of Degas's tireless studies of everyday situations. Plainly the artist relishes showing the play of light on the bath towels and the pedicurist's bald patch; the translucence of the towel draped over the chair is particularly well achieved.

Degas's portrait of *Estelle Musson* (p. 25), done in 1872/73, is one of the daintiest in touch that Degas ever did. It is a flood of delicate whites, greys and pinks (in the gown) and background), with only the belt and her hairdo offering the eye an arresting purchase. Estelle looks lost on her canapee, hands resignedly folded in her lap. Not long after marrying René de Gas, Estelle had gone blind; and Degas shows her gaze by-passing us, a vacant gaze bent upon vacancy. It is a discreet and simple portrait of one woman's solitude and isolation – of one woman among his American relatives to whom he felt especially drawn.

The most important work resulting from his visit to the USA, however, was of course *Portraits in a New Orleans Cotton Office* (1872/73; p. 23). Unfortunately none of the preliminary drawings have survived. The small picture shows fourteen men at work in his uncle's cotton office. Michel Musson is sitting in the foreground, checking the cotton; René de Gas is reading the paper; Achille de Gas is leaning by the window. Musson's partner James Prestridge is on a stool, discussing a deal with a client. The accountant is checking the books. Musson's son-in-law William Bell is offering the wares to a client, to inspect the quality.

Everyone in the picture is quite absorbed in his own particular activity, which prompts an impression of quite remarkable lack of contact or interaction. The office is not an especially big one; yet these people seem to have nothing to do with each other. They just happen all to be in the same place – which perfectly expresses a truth of the business world. Degas was planning a second, less complex version; his oil sketch *Cotton Dealers in New Orleans* (p. 22) indicates what it might have been like. With fewer people in the scene, but a far more radical visual fragmentation, it achieves a similar effect.

The cotton office painting is no mere memento of an occasion, to record all Degas's hosts in one picture; it also had a commercial purpose. Degas was hoping that an English art dealer by the name of Agnews could interest a Manchester cotton mill owner in it. The self-assured Degas wrote to Tissot: "If ever a cotton manufacturer wanted a painter, I would be his man." But the deal fell through; and so it was that in 1876 the painting, with all its old master tonalities, was seen at the second Impressionist exhibition, and in 1878 became Degas's first work to be bought by a museum. His American relatives were evidently less enamoured of the works, for Degas ended up taking every one of them home with him to Paris.

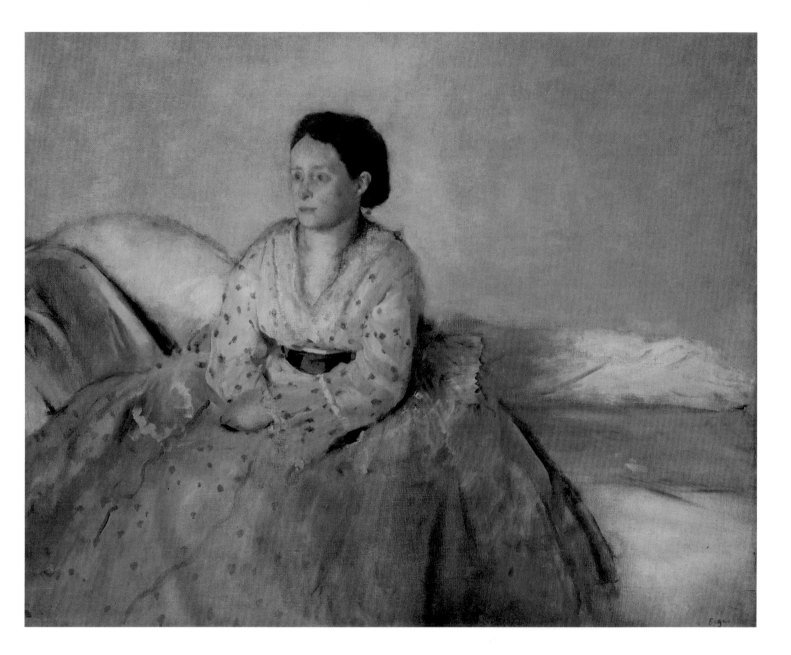

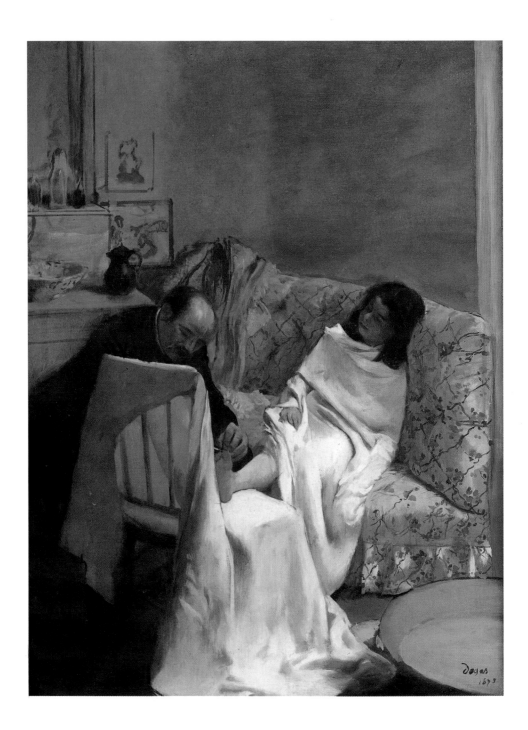

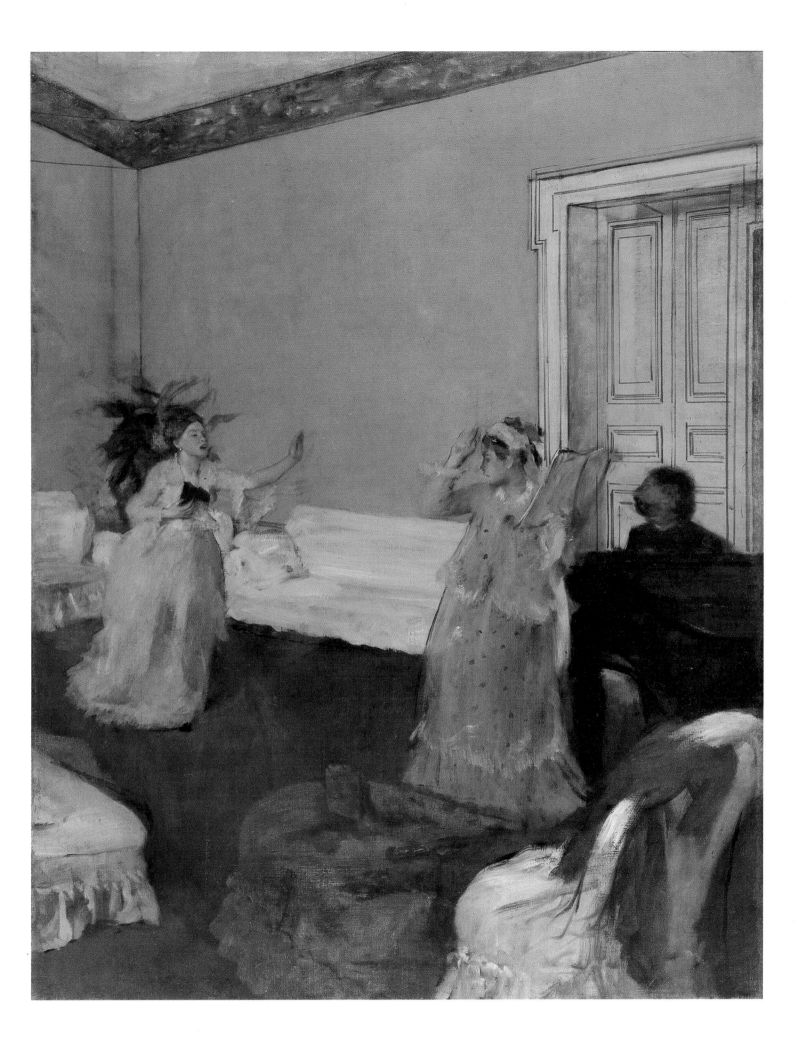

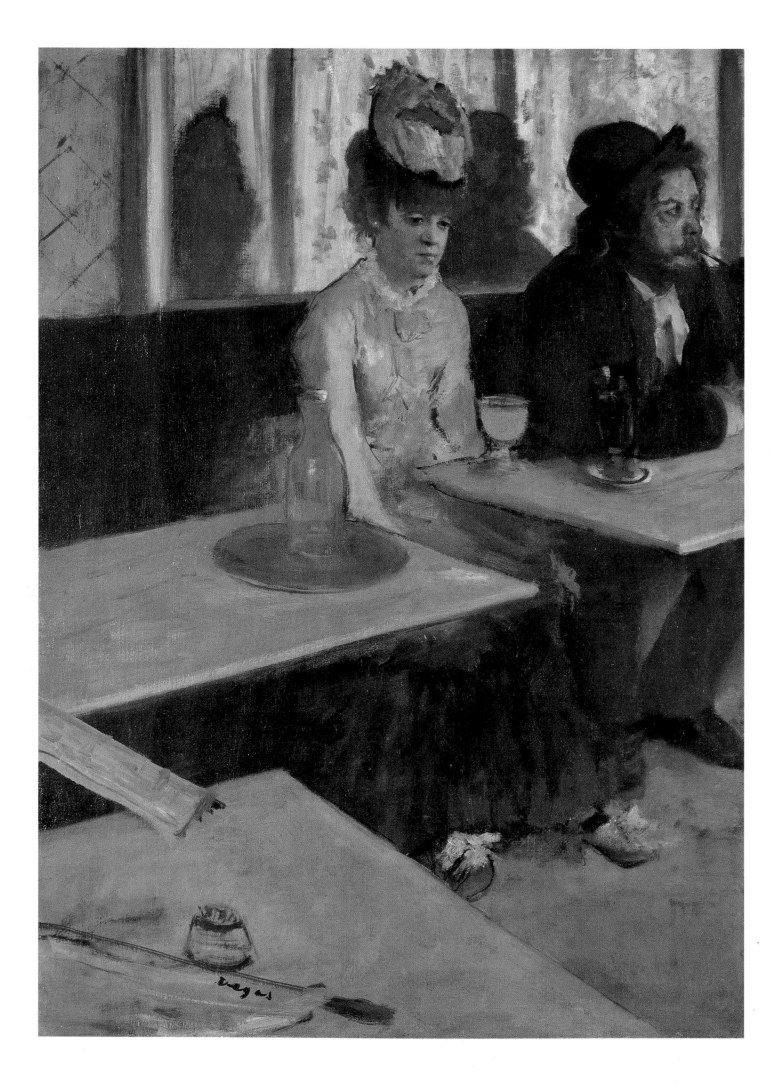

The Discovery of the Present Moment

After his return from America, Degas had closer contact with dealers such as Durand-Ruel, in an attempt to bring his work to public attention independently of the Salon. The attempt also produced a greater interest in contemporary subject matter. Not that the path he took to modernity was a direct one; one of Degas's cardinal tenets was that tradition and the present were reconcilable. This was something that Manet and Degas had in common; and by a curious coincidence it was in the Louvre in 1862, when Degas was copying a Velázquez, that the two artists met. In the 1860s Manet was at the centre of a group of artists who met at the Café Guerbois, and during that period he played the important role of a catalyst in Degas's development, helping him take his bearings anew. He introduced him to the young artists in his group, and Degas's sharp tongue soon earned him a reputation. Degas did several portraits of his new friend, showing him as a cool, stylish man.

The Café Guerbois group included writer Zacharie Astruc, painters Antoine Guillemet and Philippe Burty, and occasionally Alphonse Legros, J. M. Whistler, Camille Pissarro and Edmond Duranty. Their vigorous debates, a continuous conflict of aesthetic polarities, provided Degas with an entirely new mental environment. "Nothing could have been more gripping than those verbal duels," Monet reminisced many years later. "They sharpened the wits and filled us all with an enthusiasm that lasted for weeks, till at last an idea would acquire final form." Degas was particularly close to Duranty, a man about his own age, an art critic on the "Gazette des Beaux Arts". In 1856 Duranty had edited the shortlived magazine of aesthetics "Le Realisme"; and in 1876, for the second Impressionist exhibition at the Galerie Durand-Ruel, he published "La Nouvelle Peinture", a theory of Impressionism from a naturalist point of view. Duranty declared that art had to confront the present and "catch the appearance of modernity as it is on the wing".

In his 1879 portrait of Duranty (p. 31), Degas seems to have

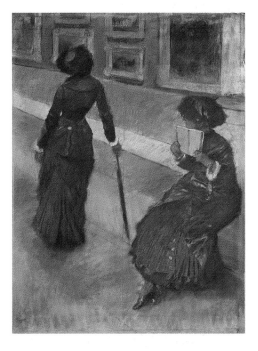

In the Louvre, about 1879
Au Musée du Louvre
Pastel, 71 x 54 cm
New York, Sotheby's

The Absinth Drinker, 1875–76
L'Absinthe
Oil on canvas, 92 x 68 cm
Paris, Musée d'Orsay

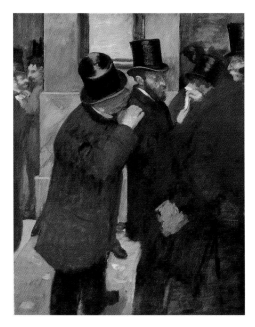

Portraits at the Stock Exchange,
about 1878–79
Portraits de la Bourse
Oil on canvas, 100 x 82 cm
Paris, Musée d'Orsay

been keeping faithfully to the letter of his sitter's law. We see the writer in his study, seated at a desk piled with papers, hemmed in by bookshelves. As Duranty's precept required, the subject's environment provides the key to his character. Still, Degas's contrast of the sitter's calm expression and eloquent gestures with a free and colourful style of painting for the setting goes far beyond mere definition of a social ambience.

In Duranty's eyes, though, he nonetheless remained "the inventor of social chiaroscuro". The expression seems apter to Degas's *Intérieur* of 1868–69, later titled *The Rape* (p. 33). Degas himself never accepted this title, always referring to his "tableau de genre". To his way of thinking, as his notebooks reveal, the picture was primarily a study in nocturnal light effects. He was especially interested in "showing the feel of evening, lamplight, a candle, and so on".

By the pale light shed by an oil lamp we see two people in a room. To the left, a woman in her undergarments has collapsed on a chair; to the right, a man is leaning against the door, feet apart. Their positions suggest conflict: "hands can still be eloquent even in pockets," commented Duranty. The contrasting light and dark of the woman's gleaming shoulder and the man's huge shadow add to the effect. We are witnesses of a scene not intended for outsiders to see; compared with *The Pedicurist* (p. 26), it is distinctly more delicate in character. Quite deliberately, Degas shows us a number of things that discharge their meaning only gradually: the still made bed, the corset on the floor, the open scissors beside the jewellery on the table, and the small case with its salmon-red lining glowing in the soft light.

The painting contains quite a number of intensified details of this kind, such as the man's glinting eye in the dark. The scene, which anticipates one by Edvard Munch, not only records the woman's abuse and humiliation but also, in the contrast between aggression and defencelessness, suggests that neither will find any escape from the fraught tension between the sexes. Degas's painting effects a startling reversal of a teasing erotic theme of the 18th century, such as we see in Fragonard's *The Bolt* (1785), where a playful preliminary tussle over the door-bolt serves to herald pastoral pleasures. In Degas's painting, both players are locked in – in the room and in their definitive isolation from each other.

In *Bad Mood* (p. 32) Degas is less interested in his narrative content than in an aesthetic quality. The painting, done in 1869/71, shows a woman looking across at us; a piece of paper in her hand, she has just joined her husband where he is working. It looks as if talk between them has just been broken off; the tension is palpable. The two are moodily taking no notice of each other; their mutual alienation is of a subtler order than that in *The Rape*. Psychological distance is present in these people's physical proximity. Degas highlights his insight by

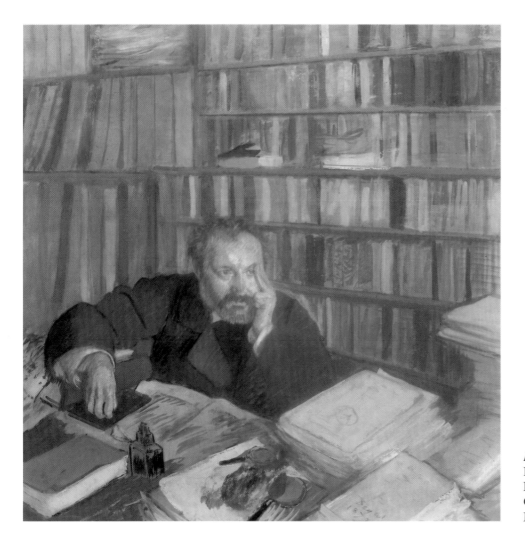

Edmond Duranty, 1879
Le Portrait d'Edmond Duranty
Pastel and tempera, 100.9 x 100.3 cm
Glasgow, The Burrell Collection, Glasgow
Museums & Art Galleries

framing both heads in the picture on the wall; the sheer movement in that picture provides a curious link between the two and a commentary on them.

Degas may have been thinking of paintings such as this one when he told Paul Poujaud that he too had taken "the Dutch road". He had a high opinion of Vermeer, and, unlike his Café Guerbois friends, valued Dutch art. He also liked the everyday scenes of the Le Nain brothers, about whom the advocate of realism Jules Champfleury had just published a book in 1862. To Degas, however, the discovery of the present moment was not merely a matter of contemporary genre work.

The Absinth Drinker (p. 28) is the best known of Degas's coffee house pictures, and indeed one of his most famous of all. It was painted in 1876 and the title was added later; Degas simply referred to it as *In the Café*. When he exhibited it at Brighton in 1876 it was bought despite savage criticism; in 1892 it was derided so loudly at another show that the collector decided to sell it.

Two friends, copper engraver Marcellin Desboutin and actress Ellen Andrée, sat as Degas's models for this café couple. Absinth was a controversial drink at the time; the high alcoholism rate among the working classes was blamed on it, as Zola's

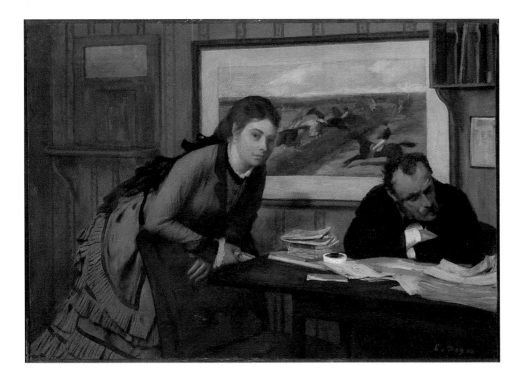

Bad Mood, about 1869–71
Bouderie
Oil on canvas, 32.4 x 46.4 cm
New York, The Metropolitan Museum of
Art, Mrs. H.O. Havemeyer Bequest, H.O.
Havemeyer Collection (29.100.43)

novel "L'Assomoir" (also 1876) makes clear. The angle of vision, the positioning of the couple, and the arrangement of the tables, establish the picture as a section of a larger view. This sectionality emphasizes the isolation and dislocation of the two. It is not hard to see what Degas meant when he said that he wanted to "portray people in their customary, typical attitudes, above all with facial expressions that match their bodily postures". The sad weariness of their faces is made the more striking by the lack of clarity in the background. The shadowy reflections express alienation; they render the two even more isolated from each other. From our slant perspective on these figures, spaces and reflections it is quite impossible to keep a grip on any clarity of relationship or any defined perception.

When Manet destroyed a double portrait Degas painted (cf. p. 34) the friendship was temporarily at an end. Degas had painted his fellow-artist listening to his wife playing the piano; Madame Manet was considered a particularly gifted player of German music. Degas gave the painting to Manet; but the latter was dissatisfied with Suzanne's face and cut the canvas accordingly. In his outrage at this wilful damage, Degas returned a still life with plums to Manet (though he soon regretted it).

The two artists shared an affinity for certain subjects which now one and then the other would discover. Horse races were one such; so was boulevard life; so was the loneliness of city people in Paris, that great capital of the 19th century. But Manet's approach to these subjects was different from Degas's. Where Degas's eye tended to accelerate time, in Manet it seemed to stand still. Both recorded alienation as a problem of city life. They did not invent their stories, but attempted to find ways of rendering experience in visual terms.

Both Degas and Manet subscribed to Baudelaire's idea that the "heroism of modern life" was the true subject of modern art. For Baudelaire, modernity constituted an entirely new historical quality; in art, modern times were fundamentally different from all that had gone before. "The painter, the true painter, will be the one who can reveal the epic side of present-day life, who can use paint or draw lines to make us see and grasp how great we are and how poetic in our neckerchiefs and patent leather boots." Degas not only read Baudelaire's occasional newspaper articles; he studied him closely. In July 1869 Manet was begging Degas finally to return a volume of the complete works which he had borrowed. It is not impossible that Degas personally met Baudelaire at one of Manet's mother's soirées.

The Orchestra at the Opera House (p. 36) confirms Baudelaire's claim that "Parisian life is rich in poetic, wonderful subjects. Wonder is all about us, it soaks into us like air, but we do not see it." Starting with a portrait of his friend Désiré Dihau, who played bassoon in the opera house orchestra, Degas painted a group portrait of a number of friends, some of whom were not in fact musicians at all. Degas was not after absolute fidelity to fact; he wanted what seemed typical of a particular so-

The Rape, about 1868–69
Le Viol
Oil on canvas, 81 x 116 cm
Philadelphia, Philadelphia Museum of Art,
Henry P. McIlhenny Collection in memory
of Frances P. McIlhenny

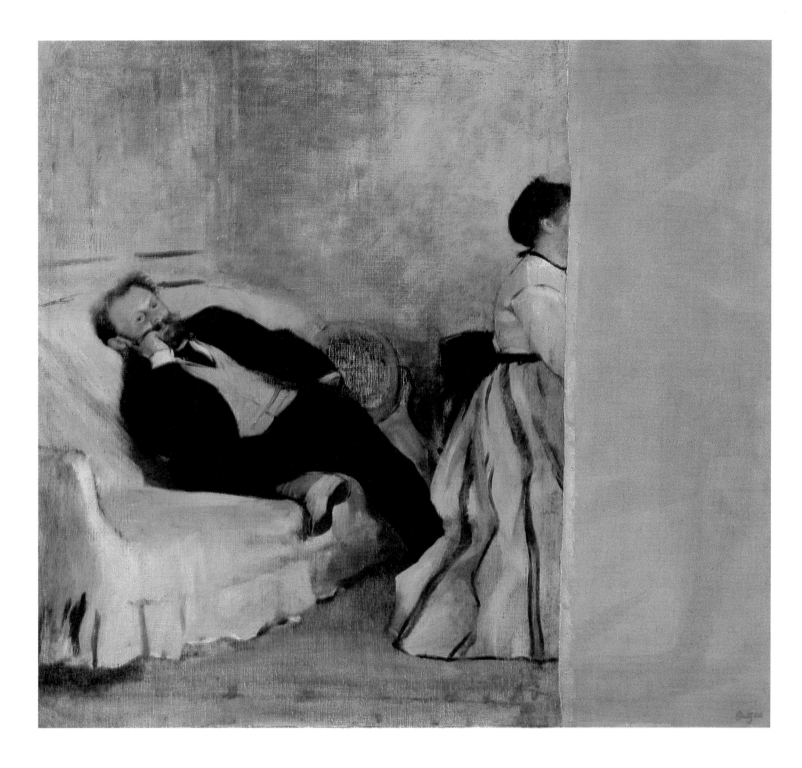

Monsieur and Madame Edouard Manet,
about 1868–69
Monsieur et Madame Edouard Manet
Oil on canvas, 65.2 x 71.1 cm
Kitakyushu, Japan, Municipal Museum of
Art

cial group. The body language of figures was not meant to present them so much as be an integral part of them. The musicians are in the orchestra pit, with brightly-lit dancers' skirts and legs providing a contrast above them and the dark auditorium. This orchestra picture, with its three-part horizontal division, established a new kind of picture, and Toulouse-Lautrec was among those who were to follow Degas's example.

Degas's antecedents were to be found in the drawings of Daumier. But Degas was not using the sectional approach to unmask his subjects; rather, he wanted to stress the authenticity of his presentation. One disembodied head in the box at top left highlights this aim. A second treatment of the subject, the 1870/71 *Orchestra Musicians* (p. 37), opposes stage and pit as

two halves of the pictorial space. We are closer than ever, with the result that our spatial perception is almost changed to a perception of planes.

In turning to the contemporary Paris of coffee houses, race-tracks, theatres and boulevards, Degas – unlike Manet – was out to capture the sense of present tempo: "One only paints what has gripped and affected one, that is to say, what is necessary." The sense of recorded fleeting moments matches the isolation of Degas's individuals. By driving his wedge into perception itself, fragmenting the stream of events, Degas was determining not only a way of seeing but the very content of the pictures.

When the Café Guerbois group re-gathered after the Franco-Prussian War, prospects at the Salon and with the critics looked bleaker than ever. As a result, Claude Monet's proposal of a group show financed by the members was readily adopted. It opened on the Boulevard des Capucines in April 1874. Degas had ten works in the exhibition. The group rather dryly called themselves the Anonymous Association of Artists, Painters, Sculptors and Engravers – which sounds more like a business cooperative than a group of avant-garde artists.

One critic, Louis Leroy, writing in the satirical magazine "Le Charivari", used the show to dismiss Monet as "impressionist", and the tag was rapidly adopted as the group's semi-official name. Supposedly Manet had said as early as 1867 that his art aimed solely to "convey his impressions". Degas always found the term unacceptable – mainly, perhaps, because he did not share the Impressionists' over-riding interest in landscape and colour. He did not care to be tied down to one method of painting. Nonetheless, Degas was to participate in all the group exhibitions except that of 1882, and even organized one himself. His financial independence made him impatient with the others, and thus difficult to get on with; he made protégés of Italian painters such as de Nittis or Raffaelli and made no bones about including them in the show, to the annoyance of his friends. Gustave Caillebotte felt compelled to voice his criticism: "He is quite intolerable. But we have to concede that he is extremely talented."

Doubtless there is truth to the criticism. Degas used the group and the exhibitions high-handedly to promote himself. Within the group he insisted on his own independence; yet he made no demur when art critics lauded him as the leader of the new school of painters. His strategy seems to have been to show off his own diversity at the exhibitions, for he always entered works that were thematically and technically very varied. In 1874, for example, along with the colourful *Carriage at the Races* (p. 41) he also exhibited *Ballet Rehearsal on Stage* (p. 48), in a style resembling grisaille work. In 1876 the meticulous *Portraits in a New Orleans Cotton Office* (p. 23) hung alongside the eccentric *Absinth Drinker* (p. 28). In 1879, as well as

"Why I never married? Well, I was always afraid that my wife might look at one of my paintings and say: 'Mmm, very nice, dear . . .' There's love and there's painting. And we only have one heart."
EDGAR DEGAS

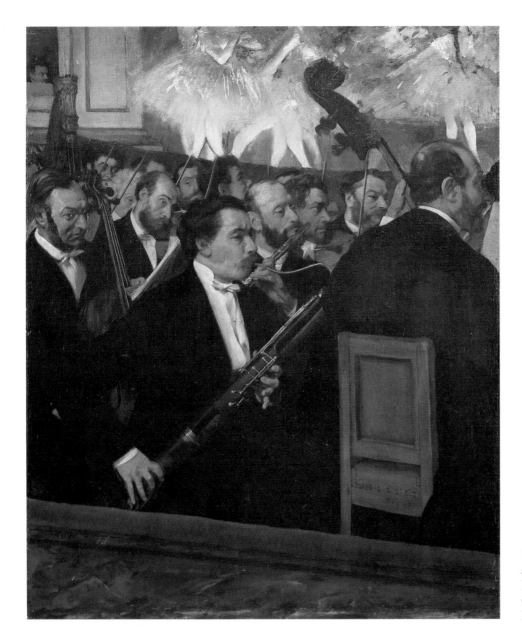

The Orchestra at the Opera House,
about 1870
L'Orchestre de l'Opéra
Oil on canvas, 56.5 x 46.2 cm
Paris, Musée d'Orsay

the dazzling *Mlle La La at the Circus Fernando* (p. 67) he had
painted fans in the show. He also regularly submitted pastels
and drawings – which had been one of his reform proposals for
the Salon in 1870. Degas's technical and thematic versatility
would have struck visitors to the exhibitions all the more
powerfully when the hanging policy was changed: instead of
mixing works throughout, the artists hung in separate rooms of
their own. And so, with his Impressionist role to support him,
with Paris and London successes to notch up and the active
help of Durand-Ruel, and with a steadily-growing number of
collectors such as Jean-Baptiste Faure, Henri Rouart and Cap-
tain Henry Hill buying his work, Degas soon became one of
the pre-eminent figures on the art scene of his day.

OPPOSITE:
Orchestra Musicians, 1870–71
Musiciens à l'orchestre
Oil on canvas, 69 x 49 cm
Frankfurt am Main, Städtische Galerie im
Städelschen Kunstinstitut

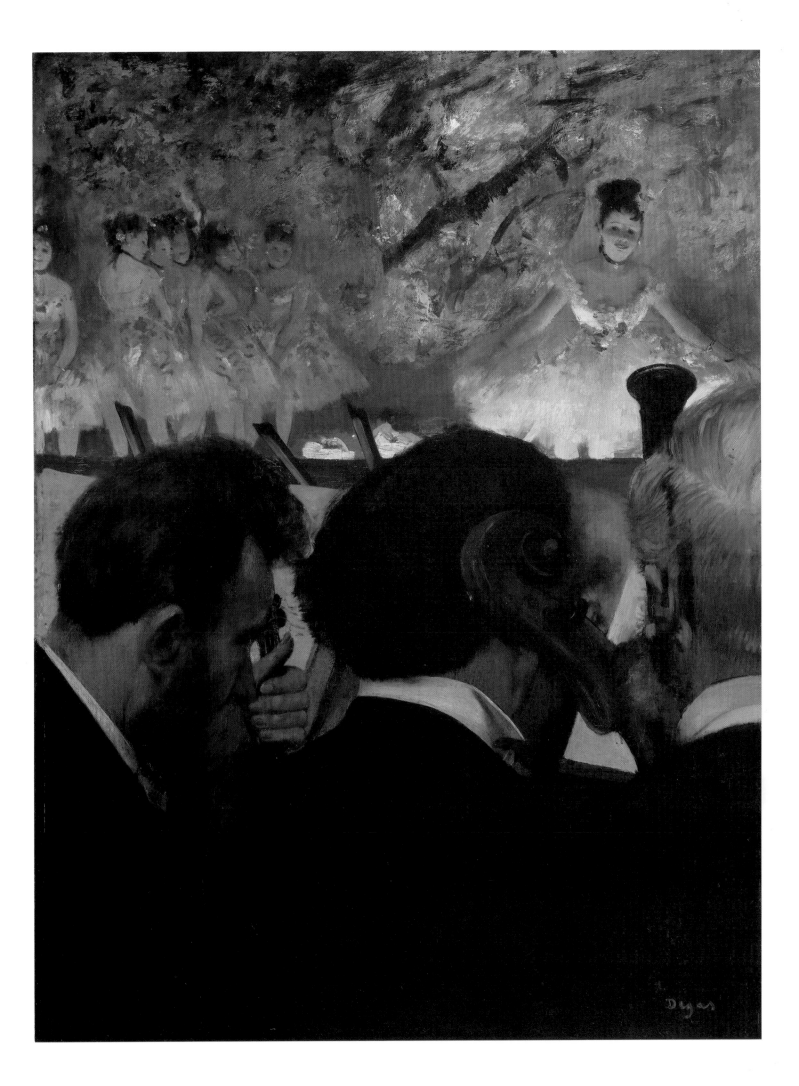

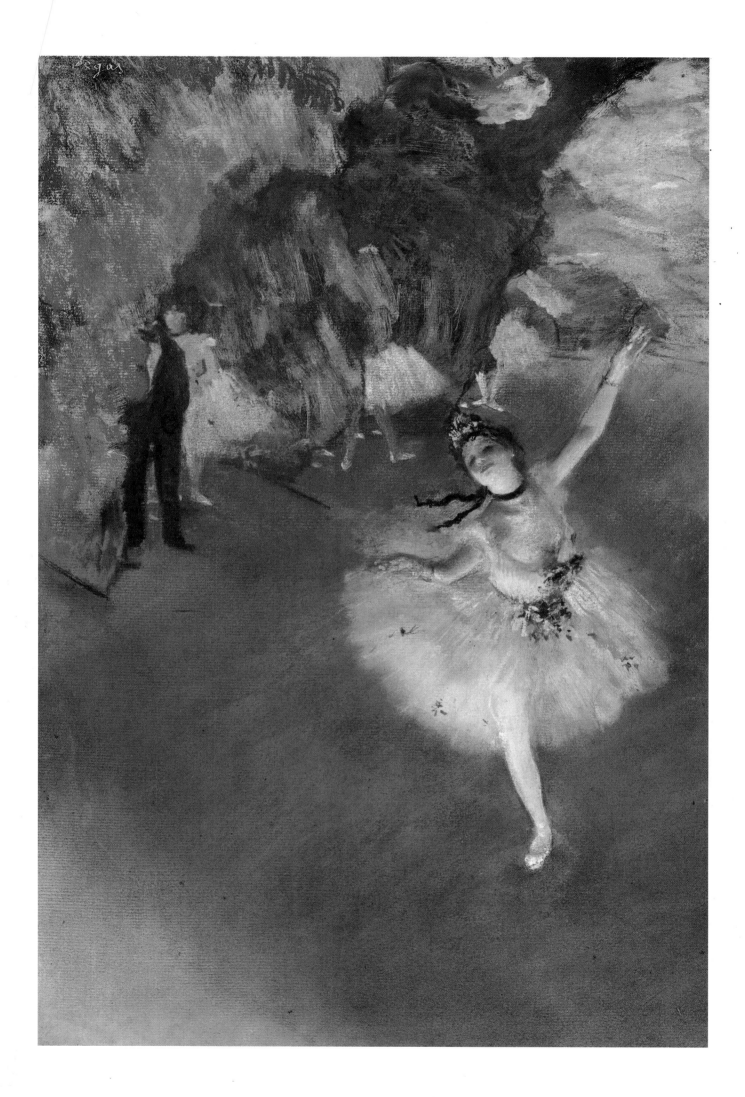

Jockeys and Ballerinas

The name of Degas is chiefly associated with certain subjects. Racetrack and ballet scenes are as closely identified with him as water lilies are with Monet or Mt. Sainte-Victoire with Cézanne. Degas discovered racetracks as a subject for art in the early 1860s; his interest had already been expressed in other pictorial contexts, though, and merely entered a new phase.

Horse racing, a sport imported from England, was a novelty in Paris at that time. The Longchamp course was opened at Napoleon III's initiative, with new grandstands in a redesigned Bois de Boulogne, in 1857. The emperor was himself an active patron of horse racing and was even involved in drawing up the rules. French horses won important races in England in 1865, and soon the races were pulling crowds of thousands and had become one of the growing metropolis's major attractions. The Jockey Club, with its blend of money, sport and politics, called the shots. Zola, in his novel "Nana", left a splendid description of the Longchamp Grand Prix.

Degas rarely painted the course itself. Paintings such as *Race Horses* (1866/68; p. 40) or *False Start* (1869/71) are exceptions. In general, the location is not entirely clear; the factory chimneys visible in *Race Horses*, for instance, could not in fact be seen from Longchamp. In that painting, Degas recorded a fleeting interplay of light and movement. A sense of restlessness builds through the depth to the nervous horse in the background. From the left, our gaze follows changes of light, from the shady grandstand across the parasols held by some of the ladies to the brightness of the paddock. Against the shades of ochre, the light and shadow set up a complex interplay. In *Horses at the Longchamp Race Track* (1871) the sheer poetry of horses' movements is not dissimilar to the mood of *Race Horses*, but now the spectators are far off and what is important is the colour qualities of the landscape and the jockeys' tops.

Carriage at the Races (p. 41), painted in 1869, is a moderately colourful work using delicate silvery greys; Degas showed it at the first Impressionist exhibition. The race itself is in the

Lady with Eyeglasses, about 1875–76
Femme à la lorgnette
Oil on canvas, 48 x 32 cm
Dresden, Staatliche Kunstsammlungen

The Star, 1876–77
L'Etoile ou Danseuse sur scène
Pastel on monotype, 58 x 42 cm
Paris, Musée d'Orsay

background; the foreground is occupied by a family scene centred on a baby, with the nurse, mother, father and (Degas's irony!) even the dog atop the box all giving the infant their undivided attention. The family is the Valpinçon family. The picture's point lies in the contrast between the action in the background and the foreground self-absorption of the family; and Degas highlights the contrast by emphasizing a random quality in the cropping of visual subjects. The barouche at left has been sliced in half by the edge of the painting. The race spectators are all isolated, wrapped up in themselves. And yet, the composition is the product of exact consideration: the horses' ears, for instance, are precisely in the vertical centre, while the tip of the mother's parasol is squarely in the middle (in terms of width). By allowing the principle of random selection into his compositional organization, Degas has not only intensified the contrast of near and far, empty space and populated areas, but has also established a new visual vitality. It has to be added, though, that by far the majority of his race course scenes focus on jockeys and not spectators, even if the broad social spectrum at the races is plainly very closely observed. The *Lady with Eyeglasses* (1875/76 p. 39) is gazing straight towards us, in a parodic reflection of the brief racing season's code of seeing and (most importantly for the city sophisticate) being seen.

From time to time Degas went to the races together with Manet, and on one occasion drew him there. Manet too did a series of racing pictures, though they are distinctly different from his friend's. His *Horse Racing at Longchamp* (1867) shows the finish, with the horses hurtling frontally towards us.

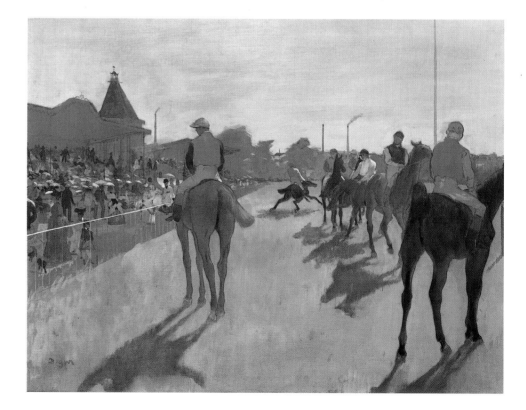

Race Horses, about 1866–68
Le Défilé
Oil on canvas, 46 x 61 cm
Paris, Musée d'Orsay

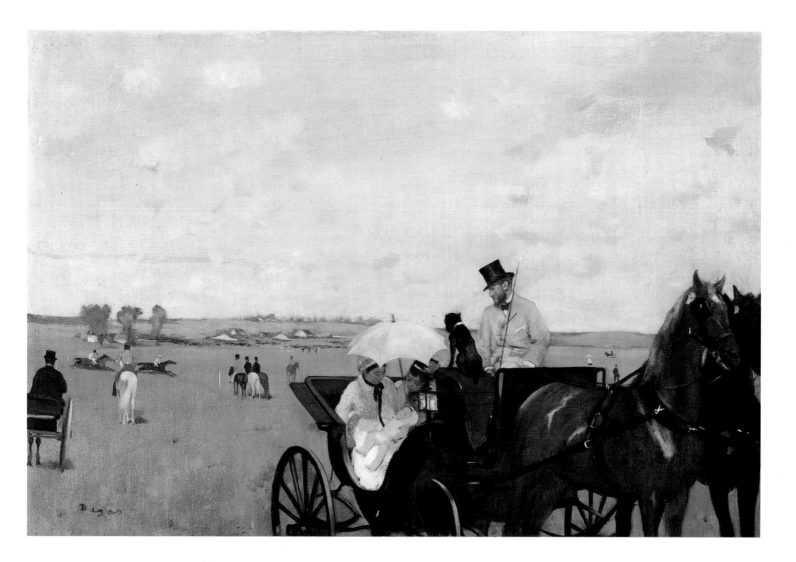

A perspective *tour de force*, the work arrestingly captures the sheer speed of the race. Though Degas's *Race Horses* is not dissimilar in its approach to perspective, the painting is not out to record speed. Movement in the Degas picture is seen frozen, and the style in which it is painted is correspondingly meticulous. Rather than being an undifferentiated crowd, Degas's spectators are a host of individual figures.

At the Races, Amateur Jockeys (p. 43) brings us closer to the action, and the spatial values have been compressed. It is difficult to see how the figures relate; they seem to be there at the dictates of chance. The bunching of figures at the right displaces attention from the centre of the picture and, together with the overlapping and cropping of horses and carriage, creates a strong impression of a chance momentary glimpse. This dimension of chance is no mere display of adroitness or compositional ingenuity, as the parallel of the cantering horse and the train in the background shows. The two movements, horse and train, echo each other: is Degas, we wonder, commenting on the rivalry of the two, or is he merely indulging in an ironic game?

In the mid-1870s his interest in the subject slackened. Colours and purely visual effects began to interest him more

Carriage at the Races, 1869
Aux Courses en province
Oil on canvas, 36.5 x 55.9 cm
Boston, by kind permission of the Museum of Fine Arts, 1931 Purchase Fund

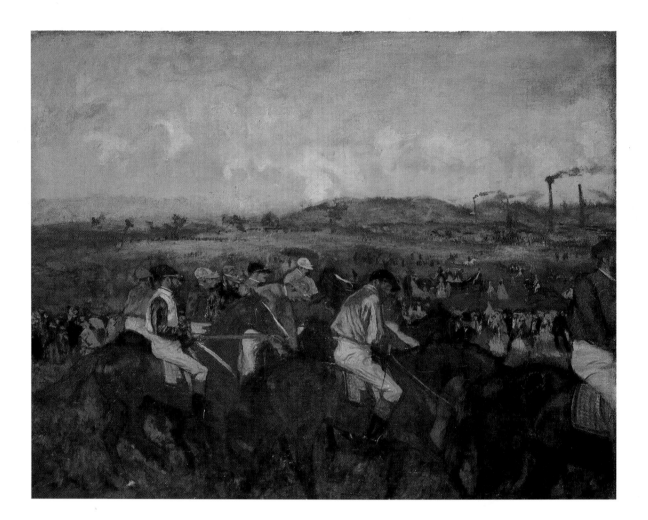

Gentlemen Jockeys before the Start, 1862
Course de gentlemen. Avant le départ
Oil on canvas, 48 x 61 cm
Paris, Musée d'Orsay

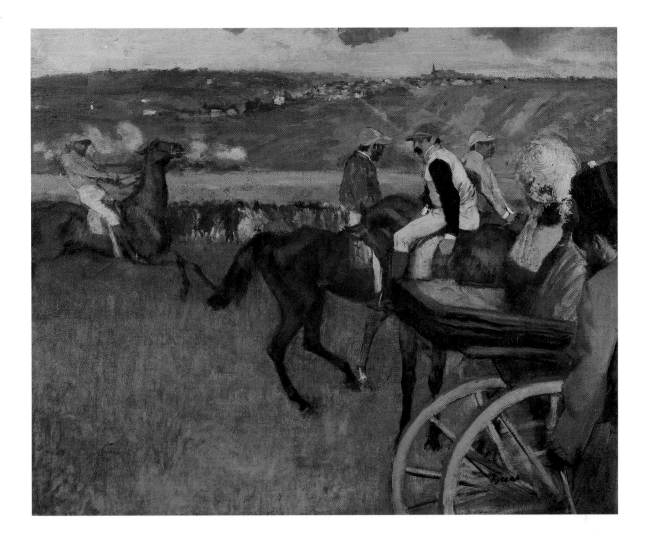

At the Races, Amateur Jockeys, 1876–87
Le Champ de courses, jockeys amateurs
Oil on canvas, 66 x 81 cm
Paris, Musée d'Orsay

PAGES 44/45:
Jockeys, 1882-83
Oil on canvas, 26.4 x 39.9 cm
New Haven (CT), Yale University Art Gallery,
Gift of J. Watson Webb B.A.,
1907, and Electra Webb

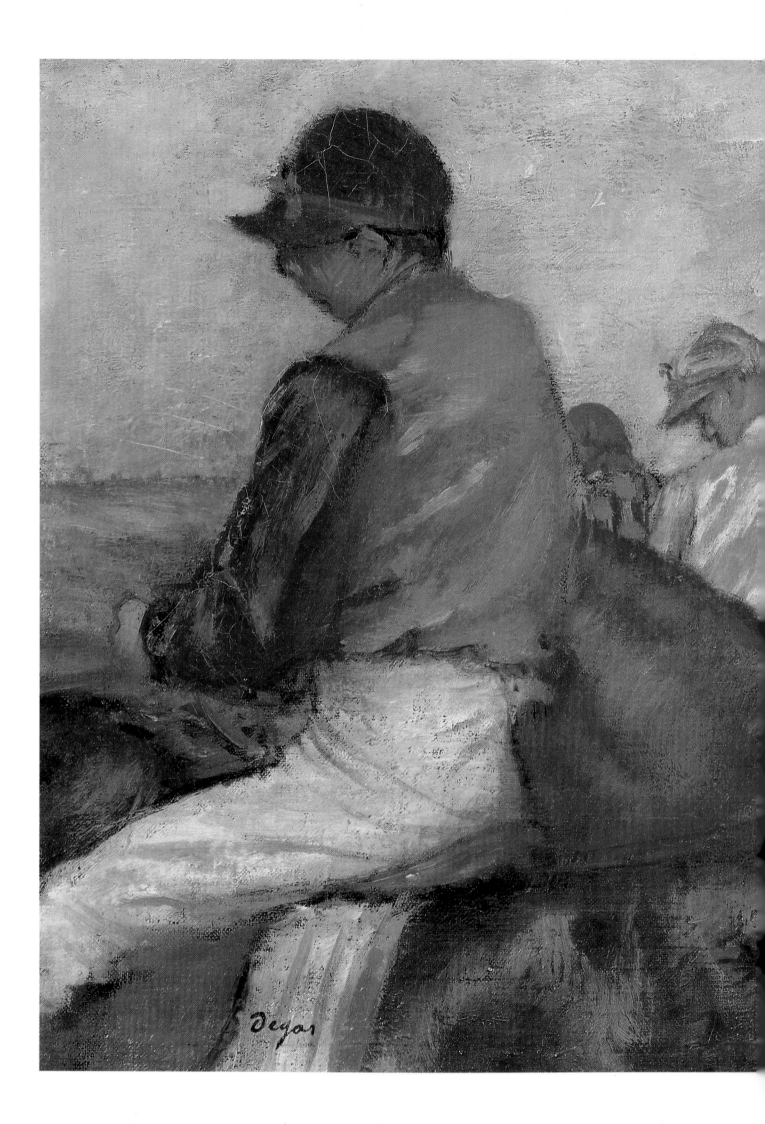

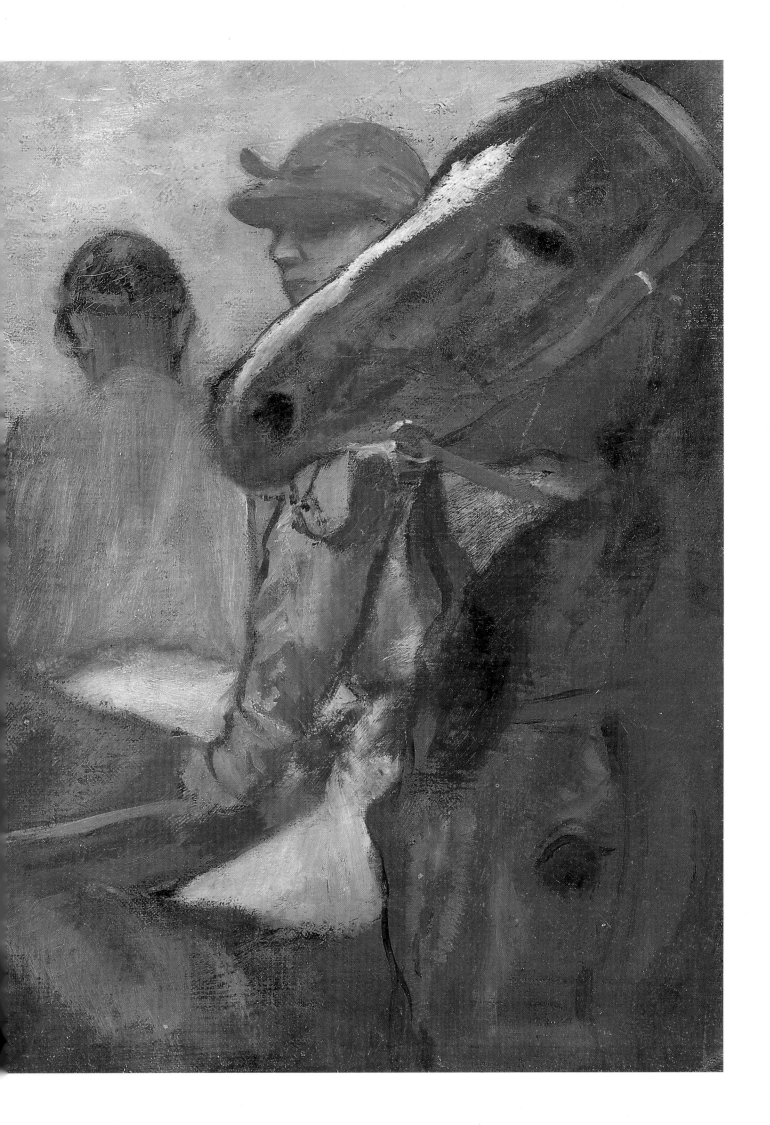

than the races as such. *Jockeys* (pp. 44/45), painted in 1882/83, is a jostling canvas that gives us a sense of being in the thick of it. Degas merely suggests his visual effects, and we are there, in the midst of a bustling scene. These hints are enough; we can easily reconstruct the agitated mood from the fragments we are offered. The sense of movement is not a spatial one here; rather, it derives from the compositional pressure generated by proximity and by the brightly contrasting colours of the jockeys' tops.

Degas rarely painted the actual races. He preferred to look elsewhere. He was fascinated by preparations for a race, by false starts and the wait before the start, by the tension and the release of tension – all of them moments hardly laden with action. This is one good reason why the *art* in Degas's work need not be sought in his subjects. For Degas, racetracks were primarily stages on which movement could be observed. Photographs had recently opened up ways of watching that movement more closely; in 1862 Nadar had published photos of horse racing, and it is possible that in 1878 Degas was present at Meissonier's studio to witness Edward Muybridge's experiments that revolutionized the photography of movement. Using horizontal sequentiality or diagonal lines of horses, most of them either entering or leaving the visual area of the picture, Degas was capturing entire sequences of movement. Even the most fleeting of movements was recorded by means of hard, precision work; it was Degas's conviction that "one conveys a sense of the truth by means of untruth". His racetracks merely afforded backdrops for movement, and his jockeys were no more than conceptual figures going through imaginary motions calculated by the artist.

Even more than his jockeys, it is Degas's ballerinas who

Dancers Climbing the Stairs, about 1886–90
Danseuses montant un escalier
Oil on canvas, 39 x 89.5 cm
Paris, Musée d'Orsay

Ballet Scene, about 1878–80
Pastel on monotype, 40.8 x 200.4 cm
Whereabouts unknown

have determined his popular image to this day. From 1870 he increasingly painted ballet subjects; among other reasons, they were easier to sell, and the family bankruptcy left Degas needing money. Durand-Ruel the dealer later reported that even in those early years the collectors "were forever only wanting dancing girls". Half in jest, Degas referred to them as "my merchandise". First he painted a series of ballet rehearsal pictures. *The Foyer of the Opera House* (1872; pp. 54/55) shows ten ballerinas being examined in the great hall. The white-clad Louis François Mérante, instructor and subsequently *maître de ballet* at the opera house, is giving orders which the dancers have to follow. Those who are not busy exercising are watching the ballerina currently being examined with close attention. The work is organized around the polarity of group and single figure; ochres and greys are prevalent, with occasional coloured bows to add highlights. The scene, remarkable for the rigour of its composition, has a distinctive energy centre in the vacant chair at the fore.

In the 1874 *Ballet Rehearsal on Stage* (p. 48), by contrast, Degas is out for atmosphere. The glare of the limelight contrasts with the rich shadows in the deep, dark stage. Degas maintained that "the attraction lies not in showing the source of light but in showing its effects". Arguably the non-colourful chiaroscuro of this work is some kind of allusion to the new visual technique of photography. The man straddling the chair functions as an observer within the scene we observe; and we notice that not only the lighting but also the unaccustomed emptiness of the theatre makes an eerie impression.

As in the orchestra pictures of the late 1860s, Degas in his

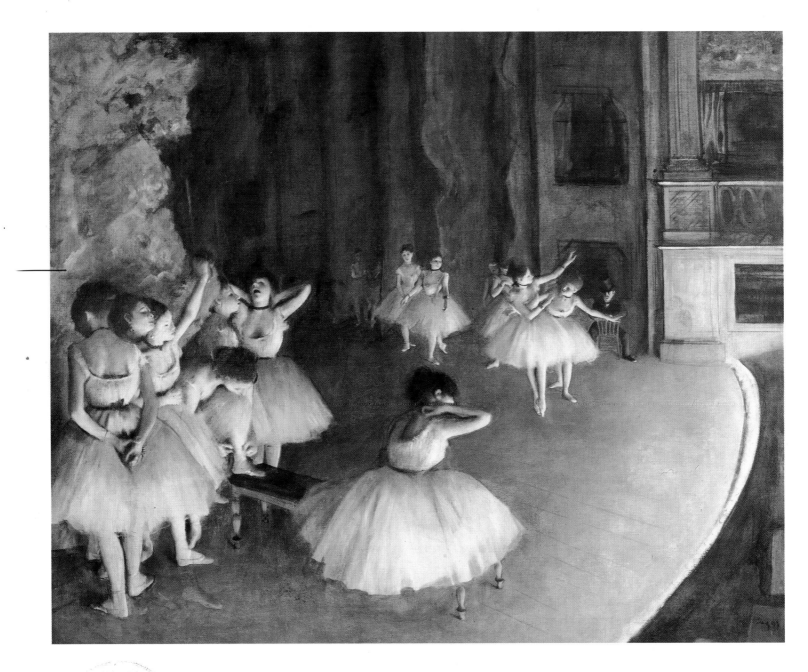

Ballet Rehearsal on Stage, 1874
Répétition d'un ballet sur la scène
Oil on canvas, 65 x 81 cm
Paris, Musée d'Orsay

ballet scenes explored the subject's potential through variations on the theme. In the 1873 *Dance Class* (p. 2) he has grouped some twenty girls and one or two mothers too, watching or comforting their daughters. Dominating the scene (and painted in as an afterthought) is instructor Jules Perrot, with the huge stick he used to beat out a rhythm. This trial session under the famed teacher is taking place in the rehearsal rooms of the old opera house in Rue Peletier, which has long since burned down.

Despite the working of the scene as an overall harmony, the girls are individuals. One is adjusting her neckband or bow, another is sitting on the grand piano scratching her back. These individual gestures have become part of an overall impression, though; in creating this, Degas can still use even the smallest scrap of individual detail, such as one girl hastily reaching up to her earring.

A year later Degas painted *Dancing Examination* (p. 51), at first glance a very similar picture, but in fact harder and less uni-

fied than the first. Degas has dispensed with the marble pilasters; this time, with its black-framed mirror, the room is an altogether more austere place. The background seems close to us, but the floor, no longer marked out in perspective-enhancing diagonals, is divided by horizontals that seem to swallow space. The details have all been very slightly altered; the painting that results is quite different.

Since the latter 1870s, Degas had increasingly been using studies of ballerinas' movements as a means to unusual perspective effects. His interest in showing particular individuals and situations waned; the point of his art lay less in what was seen than in how it was rendered. The same figures (such as the ballerina scratching her back) reappeared in new configurations. At the same time, the pictures became more colourful and the chosen sections more fragmentary. As in the jockey pictures, observation of forms *of* movement led to the construction of forms *in* movement.

The Star (1876–77; p. 38) shows the star of the show dancing a solo turn on an empty stage. Other dancers can partly be seen waiting in the wings. The ballerina is on her toes, completing an arabesque which Degas renders very precisely through the positions of arms and the one visible leg and the slight inclination of the head too. The sense that we have glimpsed a real passing moment is enhanced by the wispy lightness of the flower-speckled tutu and the trailing tapes of her black velvet neckband. We are seeing the stage from the angle of vision we would have from a box; the front of the stage is not in our line of vi-

To Mademoiselle Salanville

Everything that the fine word *mime* implies,
Everything that is said of the ballet,
The body's silent eloquence – all they say
Of physical mystery in their witty lies,

Those who would pin down Woman as she flies,
Forever on the wing, severely gay,
A butterfly soul, immortal for a day,
Alive, unlike a book where pleasure dies –

All that, and the grace of an Atalanta,
The artful artless graces, you have, dancer.
The dance of tradition, the being and seeming,

The secret of the forest: at every dawn,
At every step I take, you are in my dreaming –
But you, you pause only to tease an elderly faun.

EDGAR DEGAS

The Ballet Instructor, about 1876
Le Maître de ballet
Reworked monotype, 56.5 x 70 cm
Washington, National Gallery of Art,
Rosenwald Collection 1964

sion, the ballerina is out on the right, and the empty stage takes up most of the field. The asymmetry of the composition reinforces the impression of a glimpse of the fleeting moment. And yet the movement has a strangely frozen quality, as if the sheer emphasis of the prima donna's movement suspended our sense of action. Like the figures on Keats's urn, the ballerina cannot move on through time; and she even looks as if she might fall over, since the slant-angled perspective of the stage has something of the abyss about it. Degas is not recording the continuity of movement, but rather the "forever" of arrested movement. The solo dancer is the only figure we can see uncropped; even so, she makes a fragmented impression – one leg is invisible because of our angle of vision, so that she is balanced on the other like a flower on its stem. Movement is paradoxically both signally present and conspicuously absent in the work, and Degas, in recording a simple ballet scene with such verisimilitude, has afforded us a curiously disturbing view of the abyss.

Degas certainly had an eye for the hard work dancing requires. His pictures tell an unvarnished tale of tough exami-

Dance Class, about 1871
Classe de danse
Oil on wood, 19.7 x 27 cm
New York, The Metropolitan Museum of Art, H.O. Havemeyer Bequest, 1929, H.O. Havemeyer Collection (29.100.184)

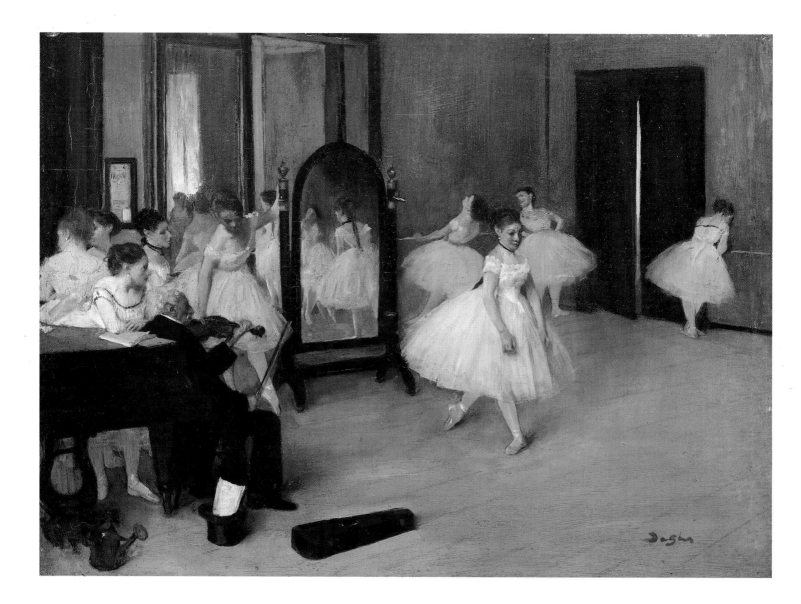

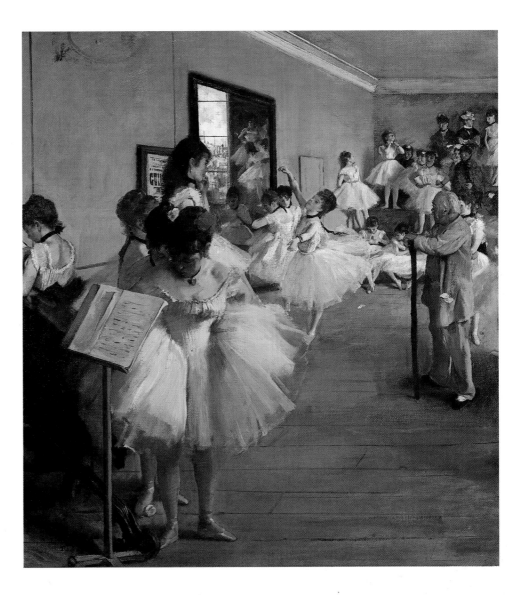

Dancing Examination, 1874
Examen de danse
Oil on canvas, 82.6 x 76.2 cm
New York, The Metropolitan Museum of
Art, Mrs. Harry Payne Bingham Bequest,
1986 (1987.47.1)

nations. (Would-be dancers from the lower classes saw ballet as a means of social and economic improvement, since they were paid according to the training they had undergone.) Degas tells of the rigours that go into producing such seeming effortlessness; he tells of the boredom and weariness of routine training. Holders of season tickets to the ballet could meet dancers behind the scenes, and it is this informal view that Degas offers. Hippolyte Taine described dancing classes as a "market of female flesh", and Degas also recorded this aspect of backstage life. He certainly knew of the sexual charge of ballet, as his eye for the girls' legs shows.

The final curtain, in an 1880 painting of that title, threatens to remove the girls from our vision altogether. The horizontals of pit and curtain cleave across the picture so violently that there is a risk of entirely dislocating our understanding of context. People no longer establish a painting's norm – a perfectly logical consequence of Degas's sectional approach to the passing moment. Yet the artist is still out to invest the moment with value; for Degas, ballet represented "everything that remains of the harmonic, unified movement of the Greeks". The

Detail from *Ballet Class,* 1881

OPPOSITE:
Ballet Class, 1881
La Leçon de danse
Oil on canvas, 81.6 x 76.5 cm
Philadelphia, Philadelphia Museum of Art,
W. P. Wilstach Collection

PAGES 54/55:
The Foyer of the Opera House, 1872
Foyer de la danse à l'Opéra
Oil on canvas, 32 x 46 cm
Paris, Musée d'Orsay

structure of time in Degas's moments is deeply ambiguous, containing "dynamic movement" and sheer paralysis at once, both motion and rigidity.

His dancers became parts of pictorial constructs which were none of their making. As in the racetrack pictures, Degas evolved from exact records of scenes to studies in movement, and so, ultimately, to compositions that were wholly invented. The vividness of his paintings results from his tireless quest for new arrangements. "The dancer is merely a pretext for a picture," said Degas. His art reveals a world where the passing and the solidly structured, appearance and truth, fiction and unfooled sobriety, can no longer be distinguished.

An extraordinary picture done in 1881, *Ballet Class* (p. 53), recapitulates these hallmarks. There is movement and the uncanny redoubling of movement. There is emptiness, and figures overlapping and cropped. And the composition is one of thorough calculation. Down the centre runs a diagonal demarcation separating Jules Perrot, two resting dancers and a mother from the three dancers currently exercising. The mother in her flowery dress and straw hat is reading "Le Petit Journal" and taking no interest in the class.

But the painting does not merely juxtapose the everyday and dance worlds. Degas has played a subtle trick with our perceptions: the glimpse we have of Paris beyond the room is not seen through a window on the rear wall – it is in fact the dancers' mirror, and the view of houses it affords us is in fact a reflection of a window view visible to the people in the room at some point behind where we ourselves must be imagined to be standing. It is a subtle interplay of spatial values, of seeing and not seeing. And it is a characteristic Degas irony that in a painting about the limits of vision and the very boundaries of a picture he depicts a figure (the reading mother) who is voluntarily accepting self-imposed limits on what is seen.

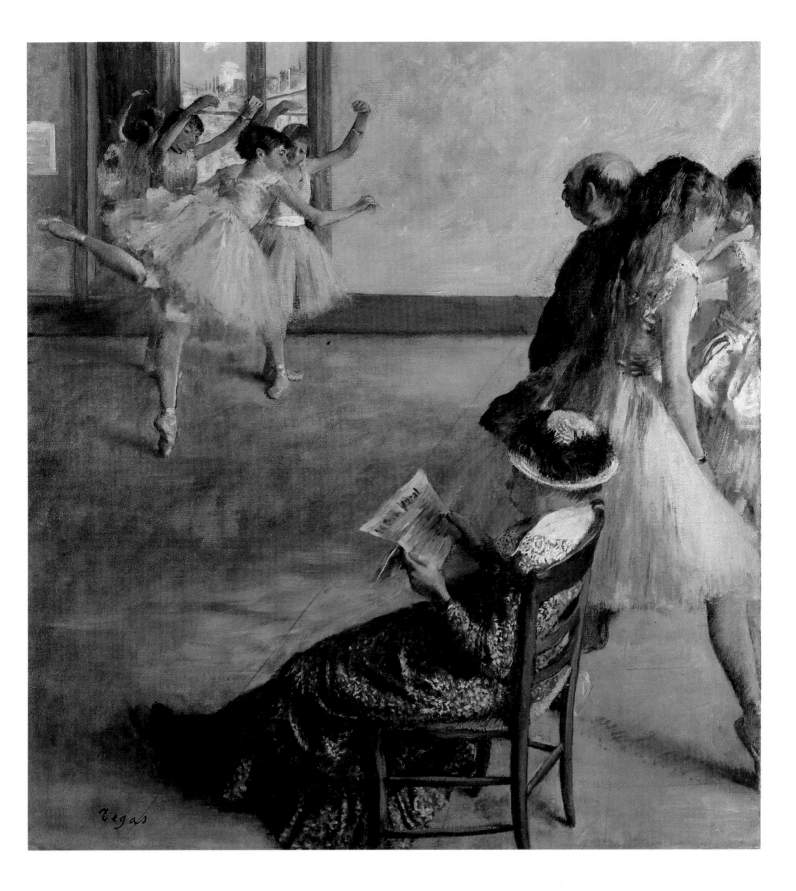

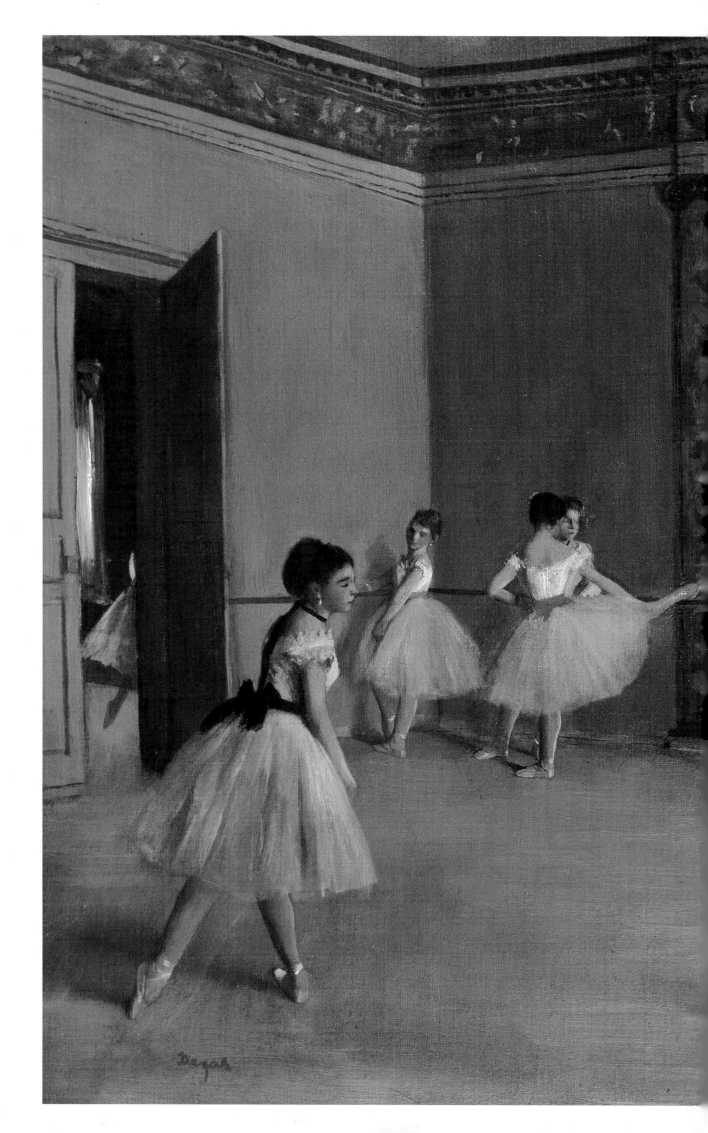

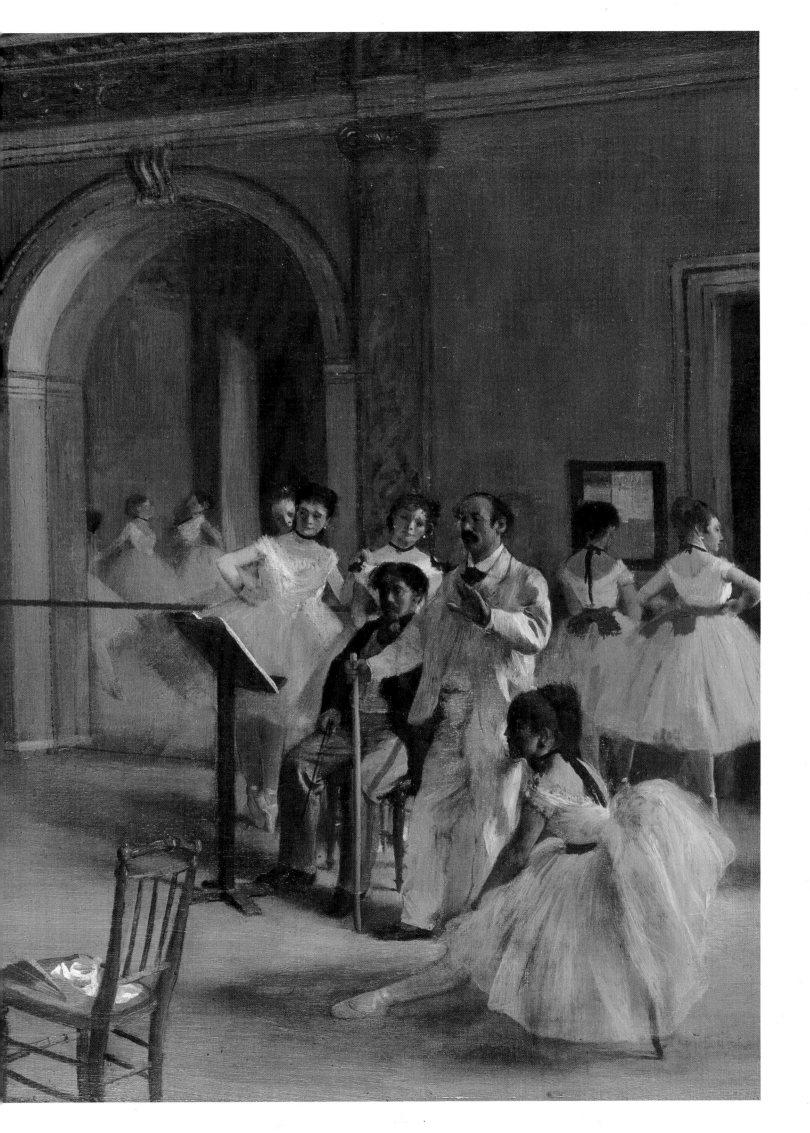

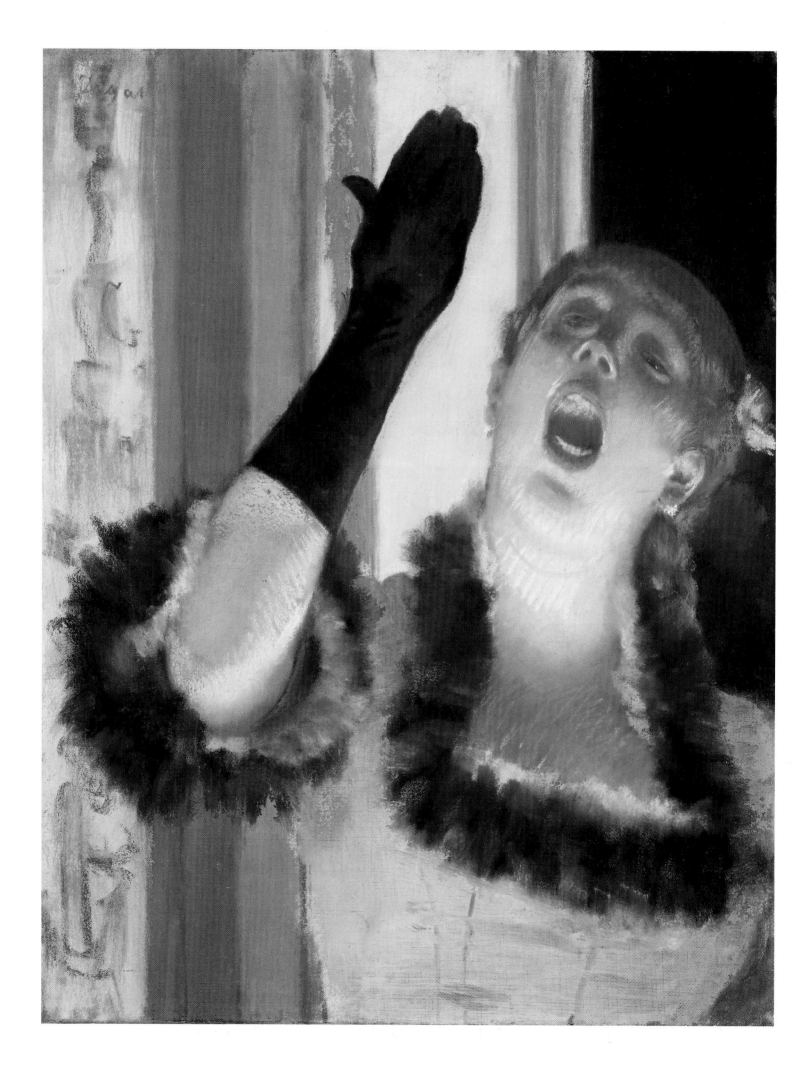

The Parisian Flaneur

In the mid-19th century the flaneur – as portrayed by the Goncourt brothers, Edmond Duranty or Baudelaire – came to be regarded as the very archetype of Parisian life. Not only did he affect particular kinds of dress and manners. He also saw everything. Bazin described the flaneur as the only true sovereign in Paris.

Degas identified with the urbane, city confidence of the flaneur, with the ease and sophistication the flaneur paraded in clubs and streets alike. The fact is that Degas was much of a flaneur himself. Paris at the time of the Second Empire and Third Republic was a rapidly expanding metropolis, with a population of 2.5 million by the end of the century. Baron Haussmann's radical re-structuring of the city had swept away old quarters and changed the face of Paris for good. Sauntering about the city, Degas was constantly witnessing new scenes of a transformed urban life, and being inspired to paint new subjects. And Degas was not the only one. In 1862, in *Concert at the Tuileries*, Manet left an account of the city's public places as backdrop for the flaneur. Degas felt that his own approach must be a similar one if he was to make full use of the chance bounty the city put his way: "To bear good fruit, one must be an espaliered tree. And stand there a whole life long, arms outstretched and mouth open, to catch what comes one's way or is all about one and be nourished by it."

His pictures recorded images of life in a modern city. And, as Degas was quick to note, this entailed fundamental changes in ways of seeing: "No one has ever painted houses or monuments from down below, as close-up as one sees them when out walking in the street." The flaneur happened upon his subjects by chance whilst strolling along a boulevard – as we can see in the 1876 portrait of Baron Lepic and his daughters, *Place de la Concorde* (p. 58).

Lepic, art connoisseur and dog breeder, is immaculately turned out. Cigar in mouth, one hand behind his back, an umbrella under his arm, he is walking across the Place de la Con-

"I have painted portraits viewed from above, now I shall do some seen from below – seated close to a woman, looking up to her from somewhere right down below."
EDGAR DEGAS

Café Concert Singer, 1878
Chanteuse de Café-Concert
Pastel (mixed media) on canvas,
52.8 x 41.1 cm
Cambridge (MA), by kind permission of
The Fogg Art Museum, Harvard University,
Bequest of the Maurice Wertheim Collection, Class of 1906

corde with his daughters and dog. He makes a blasé impression; certainly another passer-by seems to think so. Degas emphasizes the emptiness of the square as if to highlight the vacancy through which this flaneur is passing, in more senses than one. Max Imdahl justly observed that this painting sets down the conceivable maximum of contingency. It proves how acutely Degas's eye was forever on the alert for the "unanticipated moment" (Baudelaire), the moment the flaneur is really out to experience. In this composition, the fleeting moment coincides with artful construction.

Since the 1830s, the opera houses, theatres and vaudeville shows had grown in number and importance in the new Paris. Walter Benjamin observed that the flaneur's true dwelling place was the street; the flaneur "is as much at home between two rows of housefronts as others are in their own four walls"; similarly, for the flaneur, "the terraces of cafés are windowed bays from which he can look down on his own household domain after work". Artists were fascinated by famous cafés such as the Ambassadeurs or L'Alcazar. In 1872, René de Gas left a rather indignant account of being induced by his brother to endure "dull-witted songs such as the one about the builder's apprentice and other stuff and nonsense". The café was not only a place to exchange news; it was a very microcosm of society, and in the latter half of the 1870s Degas gave it his devoted attention.

The Café des Ambassadeurs was one of the oldest that offered musical entertainment. It had now had a pavilion built on, and there were gas lamps in the garden to light up the night. In *The Song of the Dog* (1876/77; p. 65), a monotype overpainted with gouache and pastel, our gaze is drawn past the singer to

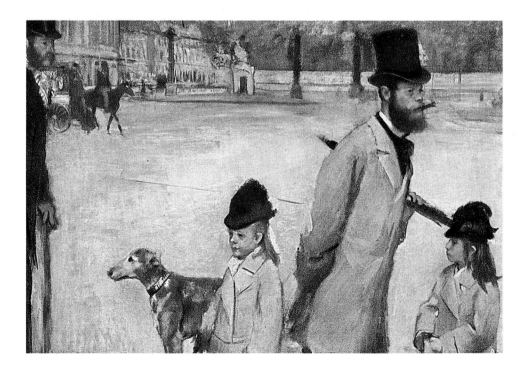

Place de la Concorde, 1876
Place de la Concorde (Le Comte Lepic et ses filles)
Oil on canvas, 79 x 118 cm
Presumed destroyed in Second World War

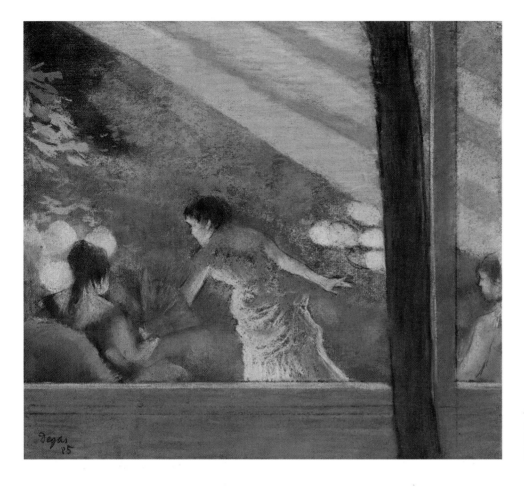

At the Café des Ambassadeurs, 1885
Au Café des Ambassadeurs
Pastel on etching, 26.5 x 29.5 cm
Paris, Musée d'Orsay

the auditorium and the lighted garden. The singer is Emma Valadon. Degas was fascinated: "She opens her large mouth and out comes the most sensuous voice, the finest, the most unphysically tender, that can possibly be." Ironically concentrating on the singer's mimicry and gestures, Degas highlights the attentiveness with which the audience are following her performance. The sheer visual wit of portraying the singer as she mimics the dog in her song is doubtless meant to underline the vulgarity of the song.

But Degas did not merely observe her pose. He recorded it as pure theatre, from her lamplit rouged cheeks (with a stark background of black and green) to the affectation of her fingertipping. The pillar divides the stage from the auditorium and helps place the singer (Degas extended the monotype on three sides to establish the spatial proportions he needed); and Degas has used the compositional intersection of pillar, gas lamp and nose to mark Valadon's open mouth as the real centre of the scene, as it were. Of course, the irony already present in Valadon's animal mimicry is further intensified by the gaslit globes, which are like soap bubbles rising above the evening crowd and making an empty comment of sheer nothingness on the performance. In pictures such as this, Degas was evolving a new way of seeing, a way that came straight from the cafés themselves.

The 1877 *Women on a Café Terrace in the Evening* offers a similar view from a café interior out onto the street. The pillars

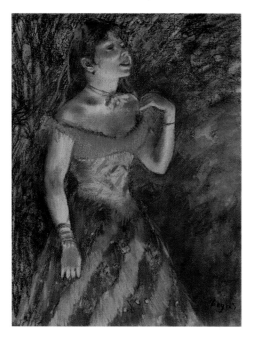

The Green Singer, about 1884
La Chanteuse verte (la chanteuse de café-concert)
Pastel on blue paper, 58.4 x 45.7 cm
New York, The Metropolitan Museum of
Art, Stephen C. Clark Bequest, 1960
(61.101.7)

divide the view into segments, so that the picture affords a number of sectional fragments such as the silhouette of a man out walking or a brief gesture of fingers at a mouth. Taken together, these fragments add up to a typical coffee house scene.

An 1878/80 charcoal drawing highlighted with pastel, *Two Studies of Café Concert Singers,* shows the same singer in the same pose from two different angles. Her pose is an attitude interpreting what she is singing; her head is nestling into her shoulder, her hands are in an imploring gesture, and she is the very image of despair. Degas has plainly been trying to find the best way to capture that image.

In *Café Concert Singer* (1878; p. 56) the gesture is seen as important in itself. This juxtaposition of face and glove was later borrowed by Toulouse-Lautrec for his portrait of Yvette Guilbert. In Degas's picture, the woman was not a singer at all; she was a well-known pianist, Alice Desgranges. Degas was not out to convey singing as performance; rather, he was exploring various shock effects produced by so extreme a close-up. Though the woman's face is doubtless correctly rendered, given the angle of vision, her features nonetheless look oddly disproportioned. The lamplight from below produces a caricature effect. In his ballet scenes, too, Degas was always interested in the curious insubstantiality of things when seen in artificial lighting, and fascinated by the way colours became acidic or pale and shadows acquired a phosphorescent gleam. A picture such as this demonstrates clearly that brighter lighting implies the loss of subtle auras and atmospheres (as critic Wolfgang Schivelbusch has pointed out). Gaslight and an evening sky, for Degas as for Baudelaire, stood for an unusual beauty, using artificial brightness to highlight both the dreamy and nightmarish aspects of people and objects. Limelight on a singer does more than illuminate a scene: it creates it.

The singer is startlingly close to us. In fact, we are looking right into her open mouth. Degas's sketchbooks show that he drew studies of grimacing mouths and exaggerated gestures at the time, with the caricature grotesqueness of the expressions very much in mind. But here the effect is primarily achieved by the closely-focussed sectionality. The picture has lost none of its power to startle, even as it insists on its authenticity. The black glove, looking as if it were stencilled, bears a full charge of expressive movement. The gesture does not express the person's mood; rather, her character is perceived by us as an extension of that one isolated and conspicuous gesture. *Café Concert Singer* represents Degas's interest in singers at its peak; his interest passed from love of song to the interaction of singer and audience and so, finally, to the singer giving herself entirely to the spirit of performance before an audience.

Degas was self-evidently using a dynamic, point-of-view approach to composition in order to break with convention. His shifts in point of view, often extreme, owed something to

photography and also something to the defamiliarization of vision effected in Japanese woodcuts, which had recently been discovered in Europe. For some time younger artists had felt imitation of Japanese art to be a useful way of avoiding the pitfalls of photographic naturalism and of Salon art alike. Interest peaked at the time of the 1878 World Fair, when crafts, interior design and fashion were all under the sign of *japonaiserie*. Samuel Bing even published an arts magazine titled "Japon Artistique", which was devoted to Japanese art and its influence on recent European art. As late as 1890 Bing organized a notable *ukiyo-e* exhibition including over 700 sheets.

Degas liked *ukiyo-e* work and himself owned a number of graphic works by Utamaro and Hokusai. The word *ukiyo-e* signifies a particular style of folk art and means "scenes of the transient, flowing world". Frequent *ukiyo-e* subjects included the lives of actors, courtesans, musicians and geisha girls, in every conceivable situation: the bath or toilet, walking, or at the tea ceremony. Degas used similar subjects, of course; but his debt to the Japanese really lay in other areas. He schooled his eye on unusual Japanese perspectives and positions, and studied asymmetrical composition, which was the most striking hallmark of Japanese art. All of this stimulated his own interest in unusual compositional techniques, such as the semicircular fan format of the 1880 *Café Concert Singer* (pp. 62/63).

Most of the fan vault is occupied by dark sky and the coffee house garden. The singer is at the right, making a lavish gesture as she sings. She is seen from the rear, coquettishly gathering up her dress. Degas may have been thinking of Mlle. Bécat, whose

"An artist has to be able to cut a great deal away."

EDGAR DEGAS

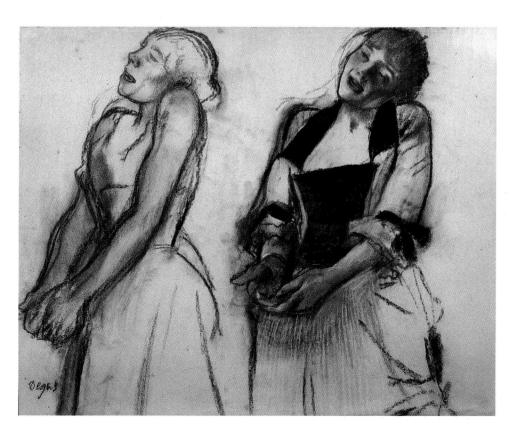

Two Studies of Café Concert Singers,
1878–80
Deux Etudes de chanteuses de café-concert
Pastel and charcoal on grey paper,
45.5 x 58.1 cm
New York, private collection

PAGES 62/63:
Café Concert Singer, 1880
Eventail: Chanteuse de café-concert
Watercolour and gouache on silk, mounted on cardboard, 30.7 x 60.7 cm
Karlsruhe, Staatliche Kunsthalle

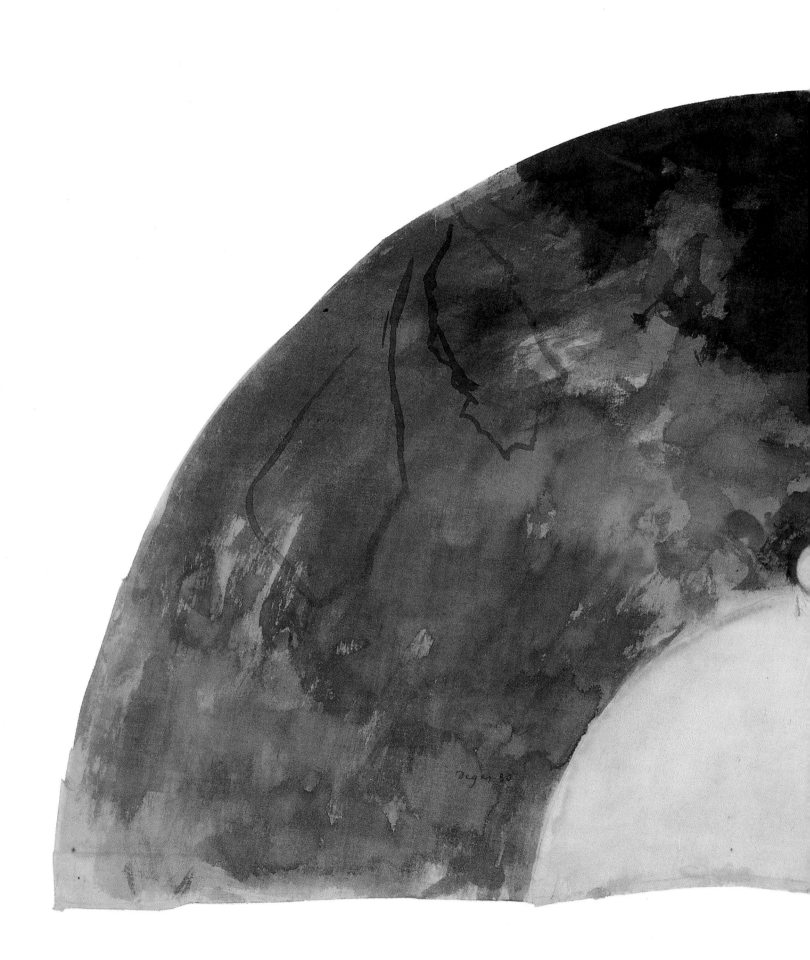

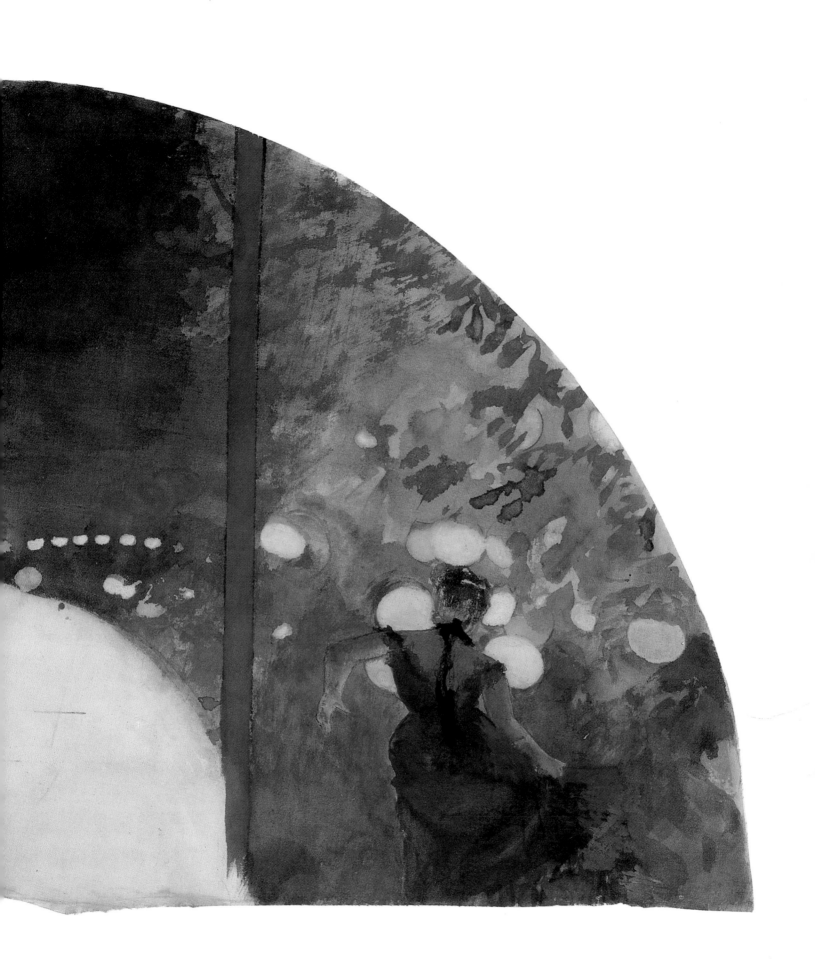

style of delivery was known as "epileptic"! Degas painted some twenty unmounted fans, using various techniques, in his quest for new compositional approaches to his subjects. In *Café Concert Singer* the fanning and the singer's gesture seem to converge, so that the format reinforces and extends the gesture. And the fact that the picture was painted on a fan meant that the action could quite literally be *unfolded*.

Essentially, what Degas adopted and adapted from the art of *ukiyo-e* was sectionality, the angle of vision, close-up technique, and greater autonomy for the vertical and horizontal values of a composition. Japanese ways of interrelating levels rather than using a central perspective prompted Degas increasingly to compose in zones and areas rather than in spatial relations. It was not only that what lay beyond or behind was now simply above. Spatial values in a picture were suddenly all in flux.

This applies, for instance, to *The Green Singer* (1884; p. 60). Seen from a vantage point diagonally above her, the singer is focussing attention on herself through her gesture. Degas had meticulously tried out the gesture and lighting effect in a preliminary drawing. The limelight from below makes the turquoise and red of her clothing and hair flare out. Degas is emphasizing the fact that the singer is being seen; he does so by stressing the circumstances in which she is seen. Quite often, Degas's use of gaze and gesture is further stressed by perspective means, so that we are forced more and more into the role of cool, distanced observers of city life. Huysmans was surely right when in 1880 he named Degas together with Baudelaire and Flaubert as one of the "painters of modern life".

OPPOSITE:
The Song of the Dog, about 1876–77
La Chanson du chien
Gouache and pastel on monotype,
57.5 x 45.4 cm
Private collection

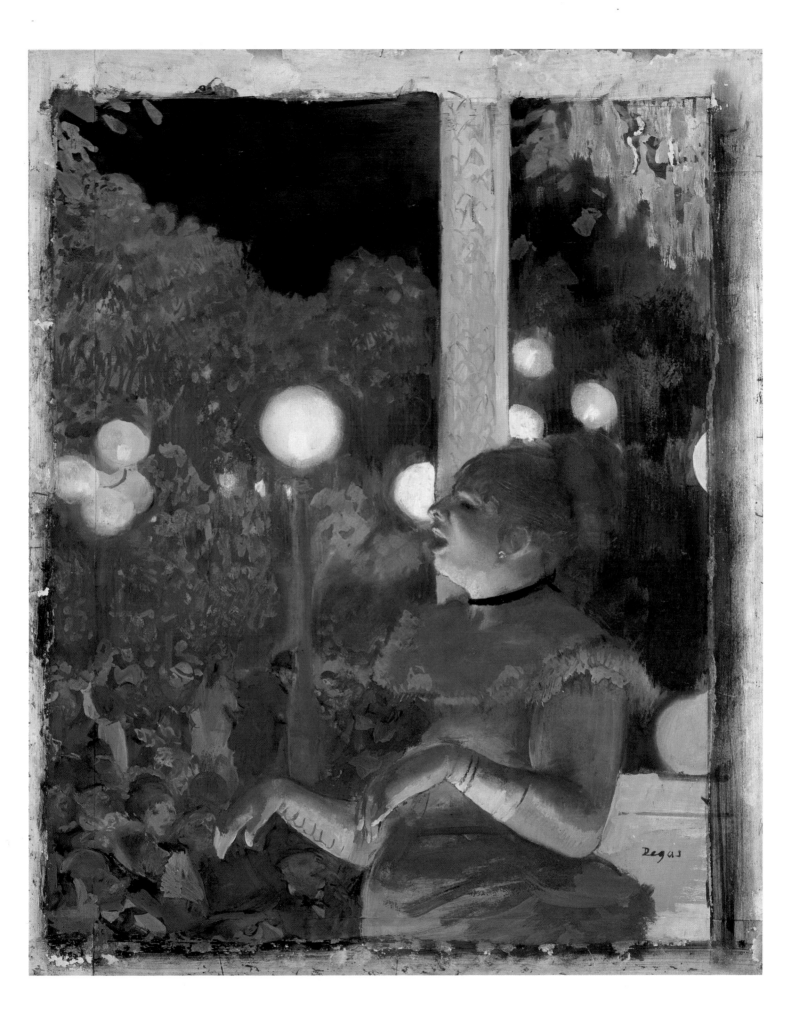

Art and Calculation

People have always been curiously affected by Degas's ability to fix the fleeting and ephemeral in the unmoving medium of a picture. The German painter Max Liebermann, who published one of the very first studies of Degas's work in 1899, observed: "At first sight, Degas's pictures give the impression of snapshots." And there can be no doubt that Degas did owe a debt to the new technology and art of photography. And yet, the impression Liebermann spoke of was born of artful, meticulous calculation – as Liebermann well knew, for he continued, "Degas is a master of creating compositions that do not look composed." Once our attention has been drawn to this, we realise that everything that appears so random in Degas's art is in fact carefully organized. One fine example is *Mlle La La at the Circus Fernando* (1879; p. 66): if it is metaphorically true to say that Degas's figures often seem to hang by a thread, then in this work it is also literally and symbolically true.

The Cirque Fernando, which had recently recently been established in 1875, was at Place Frodot; in 1890 it was renamed Cirque Medrano. It was a major attraction for Montmartre artists. From 19 to 25 January 1879 Degas went there at least four times, to see a mulatto trapeze artiste who called herself Mlle La La. She was also known as *la femme canon* because her most sensational trick was to fire a canon suspended on chains which she held in her teeth while she herself was hanging from the trapeze, hooked at the knee-joints. In Degas's painting, however, she is performing a different part of her act, and is being hauled up into the circus cupola. There could be no subject with greater fleeting spontaneity. Rotating as she goes, Mlle La La seems to be free in mid-air; the rope is only unobtrusively visible.

Degas was not out to portray the bravado of the trapeze artiste. His concern was not colourful authenticity or circus atmospherics. Instead, his attention is on the visual interplay of artiste and architecture. Everything else (the trapeze, the ring, the audience) has been left out. He did a great many sketches

Ceiling Vaulting at the Circus Fernando, 1879
Drawing, 48 x 31.3 cm
Birmingham, The Barber Institute of Fine Arts, The University of Birmingham

Mlle La La at the Circus Fernando, 1879
Mlle La La au Cirque Fernando
Oil on canvas, 117 x 77 cm
London, The National Gallery

Woman Ironing, about 1869
La Repasseuse
Oil on canvas, 92.5 x 74 cm
Munich, Neue Pinakothek

and studies of both the artiste and the cupola building. It may well look like a snapshot; but of course a great deal of careful calculation went into the composition, so that a real harmony of chance and calculation should result.

The sheer, angular viewpoint from below is a modern variation on baroque *sotto-su* perspective; because of it, the picture of *Mlle La La at the Circus Fernando* was dubbed "Ascension at the Circus". What mattered to Degas was not any past religious association of his viewpoint, but enhancement of perspective efficacy and greater authenticity. As she hangs there, we realise that the artist has stripped his picture of anything that might provide her with a safe guarantee: both the anchor and pulley of the rope are out of sight, and the only counterbalance to Mlle La La's body-weight in the picture is the slender diagonal of the rope. Though the rope naturally intersects the lines of the background architecture at random points, certain patterns do emerge: for instance, the short vertical length by which the artiste is dangling, if extended to the bottom of the picture, would meet the slant cupola timber exactly.

There is an analogous balance in the upward-pulling and down-ward-hanging momentums involved in La La's position on the rope: she is a centrepoint of tensions and forces. Of course her position in the picture, which appears randomly chosen, has its reasons. There is strict necessity in these spatial relations: the circus architecture requires that the grid of iron girders arch over to the top right, with the result that the artiste's revolving body seems caught in a web of taut linear interaction.

At first glance it looks as if Mlle La La's feet are resting on the archway at left and the fingers of her left hand are touching the upper sill. In fact, of course, the spatial proportions of this work are huge. Degas has succeeded in creating impressions of zoned unity out of compositional components that have nothing to do with each other. In the whole of this picture so strikingly made of diagonals and verticals there is not a single horizontal: everything strives upward, leaving La La literally in the air. It would not be going too far to say that Degas has rendered the circus artiste in metaphoric style as standing for the lost human condition.

Mlle La La at the Circus Fernando shows once again how distinctive Degas's iconographic world was in the Impressionist group; only Manet shared his interests in part. Both artists had a more complex sense of the new painting than the other Impressionists, who were mainly working on landscapes. From the early days, for example, Degas was interested in women who did the ironing at laundries; realist artists and writers such as Daumier, Pissarro and Zola had shared this interest. His first picture on this subject was done in 1869. The young woman looking up from her ironing did not in fact do the work for a living but was a professional model, Emma Dobigny. That notwithstanding, Degas has succeeded in recording a vacant,

remote gaze and the weary attitude of a woman in this tedious line.

By the turn of the century Degas had painted fourteen pictures on the subject, showing women ironing from various angles, singly or in twos, silhouetted or behind laundry. There are four versions of the 1884–86 picture of two women alone (p. 70). We see an unprosperous laundry, complete with stove and washing hung up to dry. It is not clear whether these women were regulars or models.

Behind the ironing table with its bowl of water stand two women; the left one is stretching and yawning, with one hand to her head and the other on the neck of a bottle, the right one is putting her whole strength into her ironing. The contrast of a relaxed and a tensed body makes more of the picture than a mere milieu study. In such pictures, Degas was exploring the darker side of city life, and the everyday alienation experienced by many. It was in this respect that they still served as a model for Picasso some time later.

Degas did over twenty pictures of milliners, too. It was a subject that Eva Gonzales had already painted before him. Paris, of course, was a great metropolis of fashion, and Degas was glad to accompany Mary Cassatt to the milliners' and seamstresses' studios. What resulted was not psychological studies but searching scrutiny of an unfamiliar way of life.

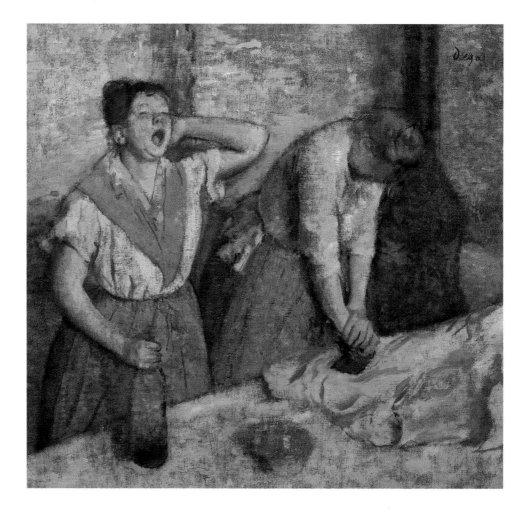

Women Ironing, about 1884–86
Repasseuses
Oil on canvas, 76 x 81 cm
Paris, Musée d'Orsay

In his pastel on paper, *At the Milliner's* (p. 72), which he executed in 1882, Degas shows a customer examining herself in a new hat. The mirror not only divides up the composition; it runs right down the milliner, so that, from our point of view, the hat she is holding out seems to be suspended in mid-air. Her face is hidden, her whole figure semi-concealed. Whatever situational contact might exist between these two women has been rendered null and void by this compositional approach.

That same year Degas painted two stylish young women in front of a mirror we cannot see; the light reflected from it falls on one woman's face as she tries on a hat (cf. pp. 74/75). The asymmetrical view and close-up position allow us a sense of chance presence in mid-scene, so to speak. Half of the diagonally-divided space is occupied by the hats on the table, where we are impressed not only by Degas's ability to imply a whole situation but also by his occasionally disputed gifts as a colourist. The colour tones sounded by the hats harmonize with one another; the circles and ovals blend with the upright stands and cane and the angled arms to establish a delightful visual rhythm. In another pastel that dates from 1879, *Lady in Town Clothes* (p. 73), Degas's interest is once again not so much in the fashionably dressed woman herself as in a certain tension of figure and space.

Degas likes to present the milliners and their clients as if they were in display windows. The people convey situations, and the situations act functionally as vehicles for compositions; in one picture, Degas goes so far as to hide the milliner completely behind hats.

In a note on other everyday Parisian scenes he was planning to record, Degas's habit of transferring his interest from the empirical facts to ways of seeing, colouring and composing becomes clear: "Series showing bakers' apprentices, in the bakeroom or even glimpsed from the street through the cellar windows; rosy flour, fine pastries, a still-life of various kinds of loaf. Big ones, oval, long, round, etc. Colour studies of yellow, rosy, grey and white loaves. Loaves in a row, foreshortened . . ." This is a far cry from the glamour of the opera and ballet; and, if we pause to reflect, our sense of the ballerinas in Degas's oeuvre undergoes a subtle change. What looks like elegance and grace is after all the product of toil too. The opera and theatre, even if their work is of an artistic nature, nonetheless do involve work.

But it is the artist's inventiveness that transforms what is merely seen into a cognitive mode. To one acquaintance who practised *plein air* painting (which Degas had no patience with), he said: "You need natural life and I need artificial." Degas's comments on his own work attest the pride he took in this: "My pictures are the product of a number of calculations and an infinite series of studies." Degas described his artistic method as a translation process in which the impressions of the moment were subordinate to a deliberate aesthetic aim and im-

Pablo Picasso
Woman Ironing, 1904
Oil on canvas, 116.2 x 72.8 cm
New York, The Solomon R. Guggenheim
Museum, Justin K. Tannhauser Foundation

At the Milliner's, 1882
Chez la Modiste
Pastel on grey paper, 76.2 x 86.4 cm
New York, The Metropolitan Museum of
Art, Mrs. H.O. Havemeyer Bequest, 1929,
H.O. Havemeyer Collection (29.100.38)

agination: "To draw what sticks in the memory: it is a process
in which fancy collaborates with memory. Only what really im-
pressed one, only what is essential, is set down. Memory and
fancy liberate one from the constraints imposed by Nature."
Degas liked to prove that a crumpled handkerchief was all the
model he needed in order to paint clouds! A flaneur, of course,
only endows the things he sees with life once they have passed
into his imagination. Degas must have derived great satisfaction
from the fact that Baudelaire too advocated Art over Nature,
the artificial over the natural.

The Impressionists (and chiefly Monet) liked to record
fleeting effects of light in autonomous systems of painted
colour.

Degas, for his part, translated contingent situations involv-
ing movement into autonomous systems of forms. It is wise
neither to overlook this nor to misunderstand it. Degas did not
subscribe to ideas of *l'art pour l'art*, nor was he a prophet of ab-
stract art. Rather, what he saw and chose to record was always
semantically charged with the principle of the random and with
laws of composition.

At a time when Salon art evaded present-day realities, at a
time when historical art was still thriving, Degas devoted his un-
restricted attention to the facts of his own present moment. The
circus artiste and the women about their ironing were alike in

that they both conveyed experiences of isolation in the every-day world.

Degas's art offers us artificial conditions of life and declares them to be normal; and it this this very declaration which draws attention to the cracks and fissures in our perceptions of everyday life. Degas's art, in short, is a devastating analysis of modern times. The flaneur, with his expertise in the quotidian, turned out to have observed the alienation of real lives far more acutely than most of the sociologists of the day.

Lady in Town Clothes, about 1879
Femme en costume de ville
Pastel on grey paper, 48.5 x 42 cm
Zurich, Walter Feilchenfeldt Collection

PAGES 74/75:
At the Milliner's, 1882
Chez la Modiste
Pastel, 75.9 x 84.8 cm
Lugano, Thyssen-Bornemisza Collection

An Eye Condition

When exactly Degas began to work in clay and wax remains unclear, though it was probably in the mid-1860s. After his death, about 150 small sculptural works were found in his studio. Only half of them were in a state to allow of bronze casts being taken, and even then often after considerable repair work had to be done. Degas sculpted in clay, wax and putty, and unsurprisingly his subjects tended to be race horses or dancers. His first sculptural work involved horses: over a dozen movement studies constituted his first venture, and doubtless he partly had Renaissance sculptures by Donatello or Andrea del Verrocchio in mind.

At the sixth Impressionist exhibition (1881) he showed his sculptures publicly for the first and only time. They had been announced well in advance; and reactions to the *Little Fourteen-Year-Old Dancer* (1879/81; p. 77) were very different. Some spoke of an "ideal of ugliness" while Huysmans discerned a "sculptural revolution". Critics were especially provoked by Degas's having clad his wax figure in a gauze tutu, satin shoes and pale yellow silk bow. Degas prepared the figure through a number of drawings and a red wax maquette, and the final result is so true to life that (in Huysmans' words) "the dancer seems alive and on the point of quitting her plinth". Doubtless it was largely because Degas shelved public ambitions for his sculpture that he succeeded in creating works that now strike us as unique in the sculpture of the 19th century. Uninhibited by academy norms or the requirements of wealthy people offering commissions, Degas blithely flouted the rules, creating "sculptural snapshots" that deliberately stripped the art of its pomp and ceremony and need not be thought inferior to the achievement of Rodin.

For Degas, a dancer was no more than a creature of movement, and he conceived his work as a record of that movement. The 1892/96 *Great Arabesque* (p. 78) shows an essential classical ballet position, and neatly demonstrates the significance of equilibrium in dance. In sculptural terms, Degas has translated

Little Fourteen-Year-Old Dancer, 1879/81
La petite Danseuse de quatorze ans
Bronze, painted in part, tulle skirt, satin
bow, wooden stand, height: 99.1 cm
New York, The Metropolitan Museum of
Art, Mrs. H.O. Havemeyer Bequest, 1929,
H.O. Havemeyer Collection

Tired Dancer, about 1882–85
Danseuse s'étirant
Pastel, 46.7 x 29.7 cm
Fort Worth (TX), Kimbell Art Museum

that equilibrium into a tension between taut stretching and a likelihood of collapse. To Georges Jeanniot he complained: "You would not credit the research and vexation that contraption has cost me. It is particularly hard to get the balance right." Seen in these extreme positions, Degas's figures have a quality of immediacy and presence in which the actual and the potential balance each other out.

Thus his dancers reach out into the space around them, and seem indeed to be growing into it. Compared with the postures approved by academic circles, these poses must have seemed wilfully unreal. Degas's lack of training in sculpture, a lack which meant his figures (supported on improvised frames) were always in great danger, was also an advantage. He was frequently helped by his sculptor friend Bartholomé, who in fact organized the first show of Degas's sculptures at the Petit Palais in 1918. Degas did not construct his sculptures from bottom to top. Rather, his figures seem centred upon a notional spatial midpoint, with axes and spatial volumes spreading out till some kind of balance, however precarious, has been established. That balance is the true subject of Degas's sculptural work: fleeting movement and construction are inseparable.

What Degas was looking for was motion that had not come

Great Arabesque, 1892–96
Grande Arabesque
Bronze, height: 44 cm
Paris, Musée d'Orsay

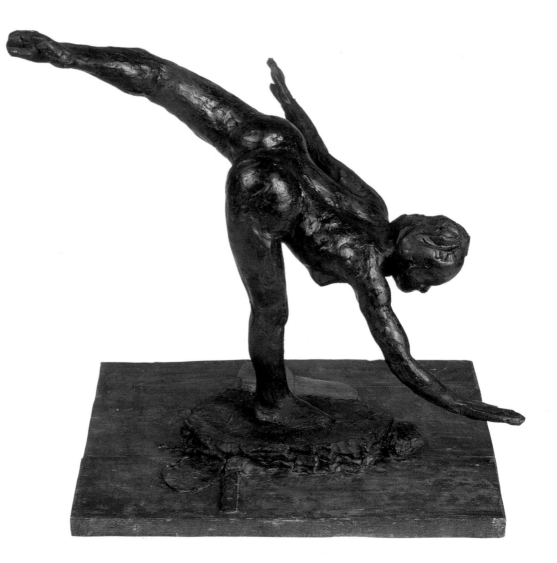

to rest. In his paintings he had used sectional views in order to question the sense of a whole, and in his work as sculptor the very instability of his creations kept a similar insight accessible. For this reason, it seems as if sculpture were already somehow present in Degas's painting. Degas pulls and extends the human body in his sculptures: lacking a frame that he can crop, he has to establish a balanced sense of volume in other ways.

This is clearly visible in *Dancer Looking at her Right Foot* (1895/1910; p. 79). In a sense, the figure is no longer a woman but a jointed construct – Degas himself spoke of the "pretext" afforded by a subject. The dancer balancing on one foot to examine her other is a successful exercise in balancing movement and stasis, contingent flux and sculptural rigidity. The structure and material are in harmony, and the dancer's movement has become an equipoised construct of opposed forces and masses.

Degas moved from verisimilitude to a looser expression of volume. In relaxing his work's dependence on the body he allowed options for a free development of spatial qualities, and it is in this that his importance as a sculptor resides. The English sculptor Paul Tucker has even rated Degas higher than Rodin. Degas himself called his modelled horses and dancers "craftwork for the blind" – a comment which should not be taken too literally, since many of his sculptural works were done between 1870 and 1880, in other words before he lost his sight.

Sculptural work was not so much Degas's response to his failing eyesight as one more strand of his continuing endeavour to locate expressive potential in various media. Wherever the possibility seemed available, he explored ways of linking graphic art and oil painting, drawing and pastel, sculpture and photography. Degas assigned the same significance to sculpture as to drawing: "Drawing is a way of thinking, modelling another." Degas was a master of both. Indeed, his sculptural work might not unfairly be seen as a peak in his exploration of artistic method.

Still, there can be no doubt that drawing lay at the heart of that exploration. Ever since Ingres gave the young Degas his advice to draw lines, he had remained true to that preference, as everything in his vast range and output attests. In 1877 Georges Rivière wrote in the periodical *L'Impressioniste*: "with a single stroke he can show everything that can be said of him, and show it more rapidly, than words can" – and it was indisputably true that Degas had an immense repertoire of drawing techniques and idioms. Unusual precision and finesse were as much his as fast, sure-touch charcoal sketching. From preparatory drawings of details (such as for *Mlle La La*) to drawings done in their own right (such as the portrait of Hortense Valpinçon), from charcoal drawings that used coloured pastel (such as the *Tired Dancer*) to loosely done gouaches, drawings

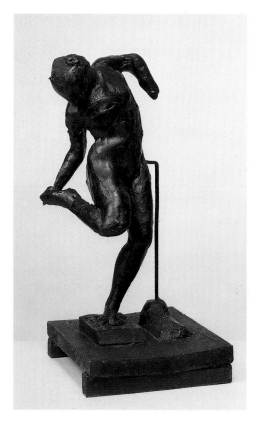

Dancer Looking at her Right Foot,
1895–1910
Danseuse regardant la plante de son pied
droit
Bronze, height: 46.4 cm
Paris, Musée d'Orsay

79

for Degas were not a tiresome convention, as they were for the Impressionists, but represented a challenge to experiment.

In his paintings, Degas increasingly abandoned a sense of precise contour, and in his drawings too he began to lose interest in strict linearity. His contours broke up, as they were later to do in Cézanne's work too; the line no longer denoted the exact boundary of a thing or body. In his sculptures this lack of definition is replicated in the restless unfinality of surface; the cursory quality of his late paintings and drawings appears as an unstable silhouette. The stroboscopic effect of many of his contour lines matched Degas's view of movement: every additional line stood for a change in the process of perception. Degas left an axiom that put his changed ideas well: "The line is not the shape; it is the way one sees the shape." Setting aside debates on colour and line in art, this comment alone highlights the importance the line had in Degas's conception of art. It also makes clear the ambiguous relations between the firm precision of a drawing and the continuously changing flux of perception itself.

Experimental by nature, Degas naturally loved the monotype. He did well over 300, the earliest in the mid-1870s but most of them in the period from 1878 to 1885. Because the process required rapid work, it appealed to Degas's needs and wishes; he liked to use the chance effects and surprises that resulted. Usually he made single prints from copper or glass plates on which he had drawn the image in lithographic ink or oil. The sheets were printed in black or brown; later, poor-quality prints served him as a basis for new work – he would colour them with pastel crayon or otherwise rework them. A quarter of his pastels are reworkings of second or third monotype printings in this way. He called them "drawings done in lithographic ink and printed".

In the early 1880s, Degas did a series of forty monotypes to illustrate Ludovic Halévy's novel *Monsieur et Madame Cardinal*, which was set in the ballet world. Or rather, Degas's sheets with hastily sketched figures and a Japanese-style spatial approach did not so much illustrate Halévy as make a parallel visual narrative. Halévy's descriptions of backstage scenes, with young beaux waiting for ballerinas, or the girls themselves hurrying down spiral staircases, in fact read as if they were descriptions of Degas's pictures. Halévy, though, apparently did not care much for the artist's work, and the collaboration was never published.

Being a mixed medium of drawing and printing, monotypes afforded Degas a means of experimenting that also gave him unusual graphic freedom. He used all the positive and negative procedures to secure a full range of nuanced tones. Lines were drawn onto the plates with a brush, dark areas of colour dabbed in with a rag. A single well-placed smudge could place an entire face. Or, in a sheet such as *Sleep* (1879/85), the light areas of the canapee and the reclining woman are brought out

against a blackened plate by means of brushes, brush handles or even fingertips.

And again Degas devised methods which are difficult to imagine in other types of art. *Smoking Chimneys*, done in 1878/79, is such a picture – a tiny monotype, barely there at all. And yet Degas tackled his subject in ambitious mood, and his meticulous notebooks recorded it as one of his important projects of the late 1870s. To submit to the element of chance in any process while at the same time remaining in control: that was the risky rule of thumb that governed Degas's work.

This technique led Degas to an area of work that he normally avoided and which the other Impressionists loved: landscape. *At The Beach* (1876; p. 81) is among Degas's few genuinely Impressionist landscapes, and it may even have been prompted by a similar work that Manet did in 1869. But this is no Manet or Monet beach scene; rather, it gathers a number of characteristic Degas motifs, such as the nanny combing the girl's hair, or the family wrapped in towels. Nor does Degas do without his little ironies, such as the steamers' smoke drifting in two different directions, or the girl's bathing costume carefully laid out to dry, both of which underline the artifice in a supposedly natural scene. He proudly told one visitor that a flannel jacket spread on the studio floor and a model had been all he needed to paint the work.

Landscapes of quite a different kind resulted from a trip to Burgundy with Bartholomé in October 1890. He worked from

At the Beach, 1876
La Plage
Oil on paper, 46 x 81 cm
London, The National Gallery

Landscape, 1890–92
Paysage (Le Cap Horn près de Saint-Valery-sur-Somme)
Coloured monotype, 30 x 40 cm
London, The British Museum

memory; and the ill-defined products recall Victor Hugo's complaint in 1837 to the effect that rail travel made it impossible to perceive landscape. And yet it was these works, in November 1892, that were shown at Durand-Ruel's gallery in Degas's only solo exhibition in his lifetime.

Degas's method of working in pastel over a monotype permitted free colour improvisation over a light and dark pre-structured fundament. In these works, Degas created phantasmagoric effects of colour. There are no people in these landscapes; the scenes are colourful impressions – of unusual sensuous power – caught in passing.

Degas was less interested in recording Nature than in relations between particular tones of colour that could be used, without any linear structure, to establish dream qualities. But he was not enamoured of hasty gabble about "conditions of the soul" and dryly retorted that it was "an eye condition". This is one more reason why these coloured monotypes seem more the work of a Rothko or a Graubner than of a 19th century artist. They are colour sensations pure and simple, diaphanous, with minimal contrast and laden with light. The exactness of line that rules most of Degas's work has for once been displaced by colour.

What makes these works different from those of Degas's fellow-Impressionists is not only the approach to colour but also his insight into the artificiality of Nature once it appears in a picture. Degas refused categorically to follow Nature: "A picture is first and foremost a product of the artist's imagination . . .!" And he had no good words for *plein air* painting: "Painting is not a sport!"

Degas insisted that the studio was the place for the creative, inventive faculty. All he needed, he said, was "vegetable soup and three old brushes dipped in it to paint all the landscapes in the world". What Degas had in mind was not so much the rule-book school of landscape art that Alexander Cozens had propagated in the 18th century, which attempted a clear-cut codification of all the elements of landscape composition. Rather, he was himself practising a free adaptation (suited to his own synthetic procedures) of the "de-forming" principle Valéry spoke of, according to which humans could become landscapes and rocks people. Thus he said of a block of granite: "What a line, beautiful as a shoulder! I shall make a steep coast of it, seen from the open sea . . ." It is in this sense that a reclining nude, perhaps a reversed print of *Sleep,* becomes an anthropomorphic coastal scene in *Coastal Landscape* (1890/92; p. 85). Landscape, as for Proust, is "a mysterious person with the broad, undefined physiognomy of a cliff, the gaze of sunset in the rain, and even the deep waters of the sea." Degas's innate sarcasm could not resist developing the human features of his landscape, though; the "male" companion piece (cf. p. 84) shows how bluntly he could choose to make his visual point. Rejecting

landscape as a condition of the soul, and insisting on "an eye condition", implies (as these pictures show) a reflexive way of seeing: what is experienced and what is invented become one and the same.

Degas even appropriated and adapted, in like manner, the entirely new medium of photography, which was first exhibited at the Salon in 1859. His attention was caught by the visual shifts which the photographic way of seeing made possible for painters. He scrutinized subjects from all round, and used visual contexts that implied things far beyond what was in the picture, as snapshots do. And at times his photographic eye was turned to photography itself, with productive results.

Late in 1895 he took a photograph of Renoir and Mallarmé in Julie Manet's apartment (p. 95). Paul Valéry has described how both sitters had to keep their poses for a quarter of an hour in the light of nine oil lamps. The photo is a portrait of two friends; Degas has posed them in such a way as to convey their personalities. Renoir, looking as relaxed as Manet in the 1868/69 double portrait, is staring straight at us. Mallarmé is leaning against the wall, looking sideways at the painter. Degas spent a good deal of time in Mallarmé's company and read the poet some of his own twenty sonnets.

In the photo, the mirror half is the Impressionist painter's, the empty white wall the symbolist poet's. But the blind patch of brightness in the mirror, right beside the camera, is where Degas should be visible. His photo juxtaposes image and mirror image. The space on this side of the scene, where the photographer and his camera (and we ourselves, looking on) are to be found, is integrated in as complex a manner as in the 1881 *Dance Class*. The photo makes clear how little Degas felt his own attitude to pictures had in common with the making of illusions. Valéry nicely described Degas as "the phantom in the mirror": that is, as impalpable a presence as one could possibly imagine. This expresses more than the intended parallel to Mallarmé; it touches upon the very essence of Degas's method as an artist. In a photograph, of all places, Degas proved that in his eyes invention and imagination ranked higher than mere exposure and recording: "A snapshot of the moment is a photograph and no more!"

Landscape, 1890–92
Paysage (Paysage de Bourgogne)
Coloured monotype on paper, 30 x 40 cm
Paris, Musée d'Orsay

Landscape
Paysage
Pastel, size unknown
Private collection

Coastal Landscape, 1890-92
Paysage
Pastel on monotype on coloured paper,
42 x 55 cm
Geneva, Galerie Jan Krugier

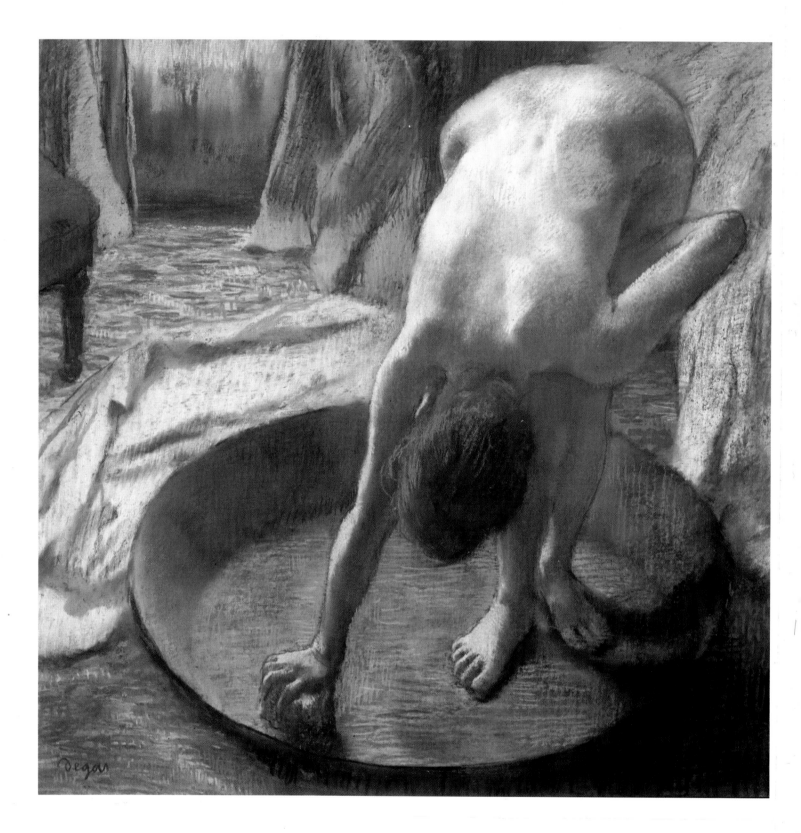

The Never-Ending Picture

In the late 19th century, pastels were largely the province of private collectors. Degas habit of exhibiting paintings, pastels and drawings on an equal footing was the exception, not the rule. Even in the 18th century heyday of the pastel portrait, the technique was considered a sign of dilettantism. Initially Degas used pastel for sketch drawings, but in the 1880s it became his preferred medium. Soon it became impossible to draw clear distinctions between his media: just as Degas liked to overwork monotypes in pastel, so too he combined pastel with oil or with gouache. His increasing use of pastel had financial reasons too, since pastels were easier to produce and easier to sell. But Degas rapidly came to value the potential of coloured chalks; and, in his series of bathing women, pastel quite displaced paint and monotype from his technical interests.

In these pictures, Degas's ability to develop a subject through a variety of visual strategies was arguably more in its element even than with the jockeys or ballerinas. *The Tub* (1886; p. 86) shows a woman bending in the bath tub to moisten her sponge. Another (pp. 92/93) done in the same year emphasizes the compositional zoning. Again we are looking down at a naked woman in a tub; she is supporting herself with one hand, the better to wash her neck with the other. On the chest at right are a number of toilet articles. The angle of vision has been so chosen as to run the edge of the chest down the picture; if it were not for the handles of a pot and a brush, we might think there were two distinct pictures. The different parts of the picture match in colour, of course, with the glowing chestnut of the woman's hair and sponge picked up in the copper pot and the strands of false hair.

Degas was forever inventing new ways of seeing and devising new approaches to his models. He did so without considering the possible consequences. In the late 1880s he did a sculpture of a woman reclining in a tub (p. 87). It was one of his largest sculptures; and it forces us to look at the woman from above. The sculptural norm, by which a figure can be seen

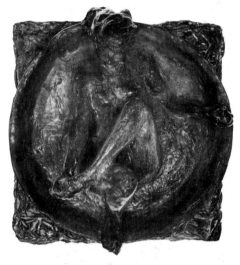

The Tub, 1888–89
Le Tub
Bronze, height: 47 cm, width: 42 cm
New York, The Metropolitan Museum of Art, Mrs. H.O. Havemeyer Bequest, 1929, H.O. Havemeyer Collection (29.100.419)

The Tub, 1885–86
Le Tub
Pastel on paper, 70 x 70 cm
Farmington (CT), Hill-Stead Museum

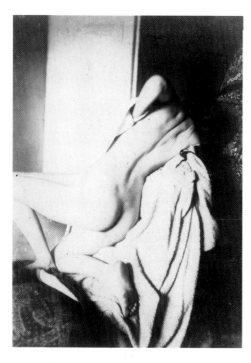

After the Bath, 1896
Après le Bain
Bromide print, 16 x 12 cm
Malibu (CA), J. Paul Getty Museum
Collection

three-dimensionally, is gone. The position in which the woman appears in a work such as *Woman Drying her Feet* (1885/86) prompted Valéry's sharp-witted insight: "In the naked figure, which he has been scrutinizing a whole life long in every conceivable manner and position, and even in vigorous motion, Degas has been seeking the unique linear system that might articulate a particular physical gesture as precisely and arrestingly as possible."

Degas was out to free the nude of poses. He refused to idealize his nudes in the style then thought obligatory. His women getting out of the tub, washing or drying themselves, were at odds with the literary or mythological approaches preferred by his contemporaries. These women are indifferent to the kind of imagined viewer envisaged by the makers of Salon Venuses. Perhaps for that very reason, unlike the Salon painters, he attracted the charge of voyeurism, even from friends such as George Moore, when he exhibited a group of these works in 1886. As long ago as the nude drawings for *The Sufferings of the City of New Orleans* (cf. p. 21) Degas had achieved the kind of directness that threw viewers who interpreted it as shamelessness or indiscretion. But Degas's gaze was a steady one: "My women are simple human beings, but honest; they are merely looking after their bodies. This one is washing her feet. It is as if one were watching her through a keyhole."

Because it was the physical presence and movements of his nudes that interested Degas, he was able to break the rules of the genre. The flaky textures of pastel chalk are subtly used to suggest a dry glow of almost symbolic quality in the women's bodies. Employing a blatantly colourful hatching technique, Degas no longer uses the line to define form or indeed volume but rather amasses lines to lend colourful vitality to entire visual zones. "I am a colourist with lines," asserted Degas; and the dictum has a precise meaning if we consider the shimmer of hatched zones in these works. Skin gleams as pure colour, embedded in a radiant surround. Degas was open to technical experiments of any kind to achieve his ends. He cursed the "diabolical work of taking the brightness out of pastel colours, I wash them time after time". He changed the technique radically and fundamentally, making it an invention all his own.

He had long been in the habit of thinking in series of pictures which could implicitly never be completed. To an extent, serial work meant that Degas could pursue a gesture or movement through a sequence of pictures, or indeed through a single picture. Nowadays, these sequences remind us of film frames. It was only in such sequences that a subject's changes through time could be recorded in terms of light and movement. Degas decreed: "One must do the same motif ten times, even a hundred times over."

Degas was one of the first artists to work deliberately with

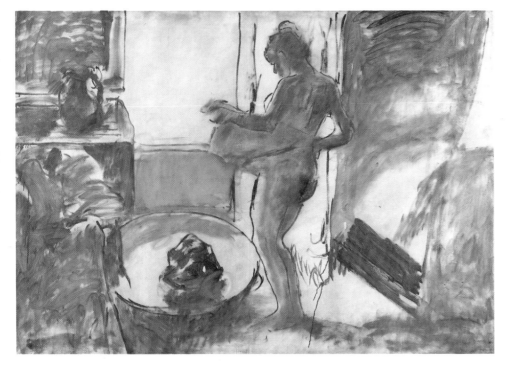

Woman by the Tub, about 1888
Femme au tub
Oil on canvas, 150 x 214.3 cm
New York, The Brooklyn Museum, ·
Carl H. De Silver Fund (31.183)

the concept of the series in order to emphasize the conceptual dimension of his art. Serial work, together with fragmented sectionalization and a curt, abbreviated style of painting, afforded a way of dismissing the idea of completeness or perfection as an integral necessity in art. For Degas, pictures increasingly implied states of transition, both in terms of subject and of medium. Monotypes became pastels; photographs such as *After the Bath* (1896; p. 88) prompted whole series of drawings and paintings. Finally it is moot to establish which was the starting point and which the development, since the images feed off and continue each other. Seen like this, every picture by Degas is potentially never-ending. The pity is that today's museums and exhibitions scarcely enable us to follow the ramifications in the way they deserve.

His self-absorbed nudes, waiting for no one, prompted all manner of speculation about the artist (who lived alone). Even Edouard Manet, Emile Bernard, van Gogh and Raffaelli liked to swap jokes and *doubles entendres* about Degas's sex life. Confirmed bachelor though he was, he was even reported to have had an affair with Mary Cassatt. His whole life long, though, ever since his early notebooks lamented his isolation, his longing to be alone and his weariness of solitude went hand in hand.

That said, Degas by no means spent his closing decades in utter isolation. He had a large circle of acquaintances and was a sociable man. Every Thursday he was at Edmond Manet's, where Mallarmé and Renoir were often to be found too. They would do things together – going to the Cézanne exhibition at the Galerie Vollard, for instance. On Fridays he dined with building engineer Henri Rouart, who also fancied himself as a

"I show them free of coquettishness, like animals when they clean themselves."
EDGAR DEGAS

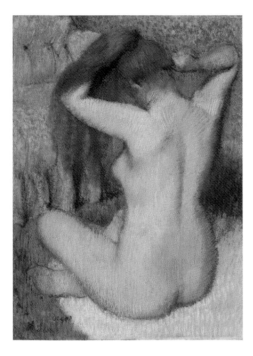

Woman Combing her Hair, about 1888–90
Femme nue se coiffant
Pastel on paper, 61.3 x 46 cm
New York, The Metropolitan Museum of
Art, Gift of Mr. and Mrs. Nate B. Spingold,
1956 (56.231)

painter. In Rouart's collection, which extended from Chardin and Goya to the present, Degas occupied a prominent position. He painted some further portraits, among them the unusual group portrait *Six Friends in Dieppe* (1885). His old friends such as the Valpinçons and Halévys were joined by new such as Suzanne Valadon, whose drawings he valued highly. Surely, as he grew older, there was more to Edgar Degas than the crotchety sharpness he was reported capable of.

It has to be said that any attempt to describe Degas the man or his work comes down to contradictions. He was mocking, arrogant and infatuated with himself; but he was also vulnerable, and a true friend. Affection for his extensive family, and a sense of duty, were dominant in his life. Yet he had little social tolerance, as his anti-Semitic stance in the Dreyfus affair (which lost him some of his closest friends) sadly proved. He was a man of contraries, and uncompromising; Mallarmé thought him "rigorous". Cool yet irascible, timorous yet razor-tongued, he made both friends and enemies all around. At fifty he felt he had wasted his life, and as he grew older he did not forbear to lash himself: "All in all I have had less courage than I hoped."

He was hardly at all the typical avant-garde 19th century artist of post-Romantic cliché. A cultivated and methodical man, of encyclopaedic breadth in art, music and literature, he abruptly switched from an early leaning towards Salon art, and became the pre-eminent painter of modern life. He was well-to-do, had enjoyed a classical education, knew his art history, and yet was well able to breach tradition and familiarize himself with the dark sides of society. The few constants in his life include his formidable powers of observation, his ability to focus vision, an old-fashioned male ideology, and a rebarbative pride. One of his duties, as he saw it, was not to expose his inner self: "Art is the governance of pain by beauty." By 1908 he was so blind that he could no longer even draw. All attempt at artistic work had to be abandoned. He was condemned to inactivity. His housekeeper reported that he was afraid of dying. And still, even into old age, he would take his customary constitutional along the boulevards. On the morning of 27 September 1917 Degas died; he was buried in the family grave in Montmartre cemetery. He had requested that only a single statement should be uttered at his grave: "He very much loved drawing."

Of the artists of his time, Degas was the one who analyzed isolation, alienation, and the abyss of public pleasure. Coolly he assembled ways of seeing; his pictures constructed the very way they were seen. His rejection of official perceptions was his avowal of art. His own way of seeing, forced though it sometimes was, mattered as much to him as his subjects: "The idea of truth is conveyed by falsity."

This brings us back to Baudelaire, and unconditional preference of memory and its constructs over immediate perception. It was a preference Degas shared, and the sharing proved

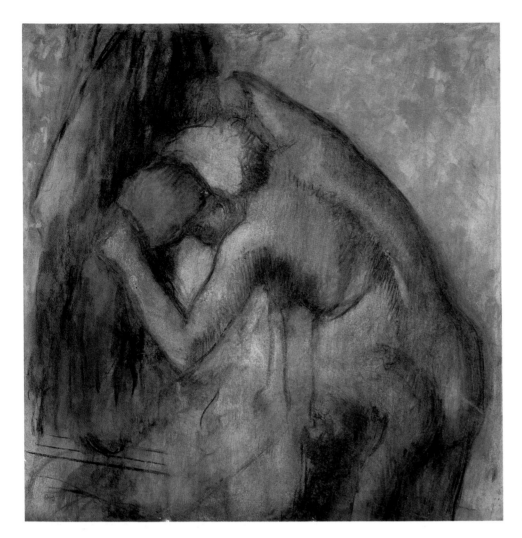

Woman Combing her Hair, 1905
Femme s'essuyant les cheveux
Pastel on paper, 77 x 75 cm
Lausanne, Musée Cantonal des Beaux-Arts

his modernity. "Modernity," Baudelaire famously wrote in his essay on modern painters, "is all things temporary, evanescent, random, and is one half of art, the other half of which is the eternal and immutable." Baudelaire saw modern art's task as prising out of modern reality the "fleeting eternity" it might contain. It is a good description of Degas's art.

Degas transformed fragmentary, random perception into images. For him, as for Mallarmé and Valéry in literature, this was a way of articulating what could not be said or shown. He rendered negative images in positive, and so made an issue of the alienation that went unseen. If his subjects were trivial and everyday, they went with a compositional perfection without compare. He has been called the most sophisticated compositional artist of the 19th century. And yet, at the very moment when we think Degas's visual world has become a mere function of compositional and painterly transactions, he demands that we see the reality in his work: "One has only to look – I have invented nothing!"

PAGES 92/93:
The Tub, 1886
Le Tub
Pastel on cardboard, 60 x 83 cm
Paris, Musée d'Orsay

91

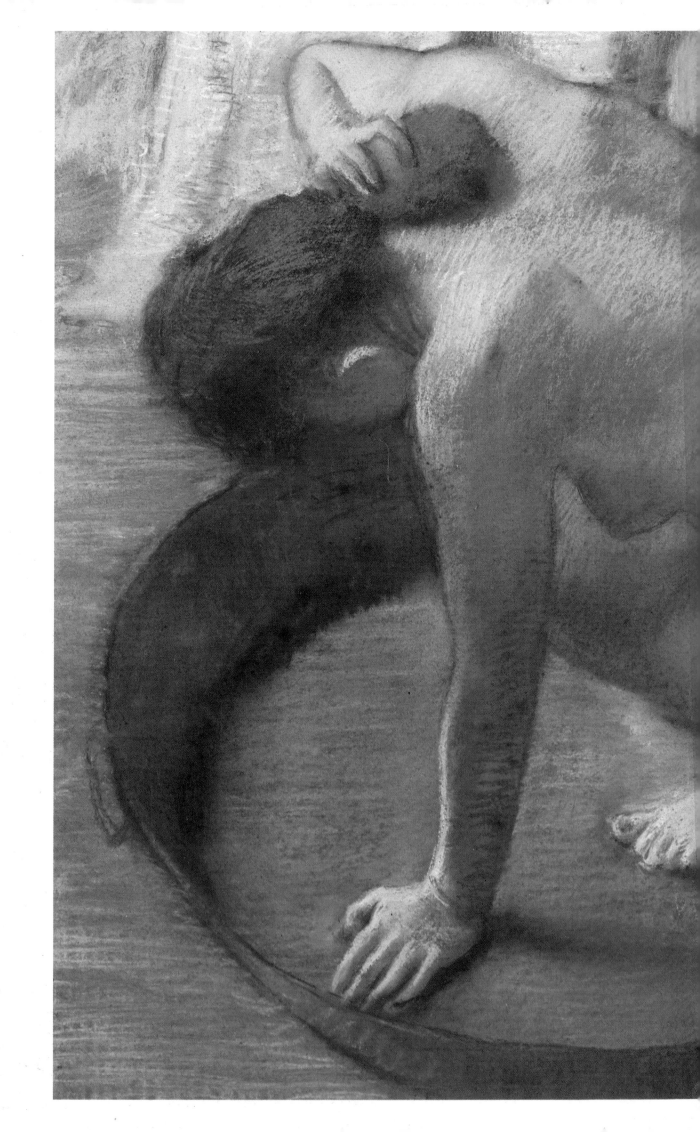

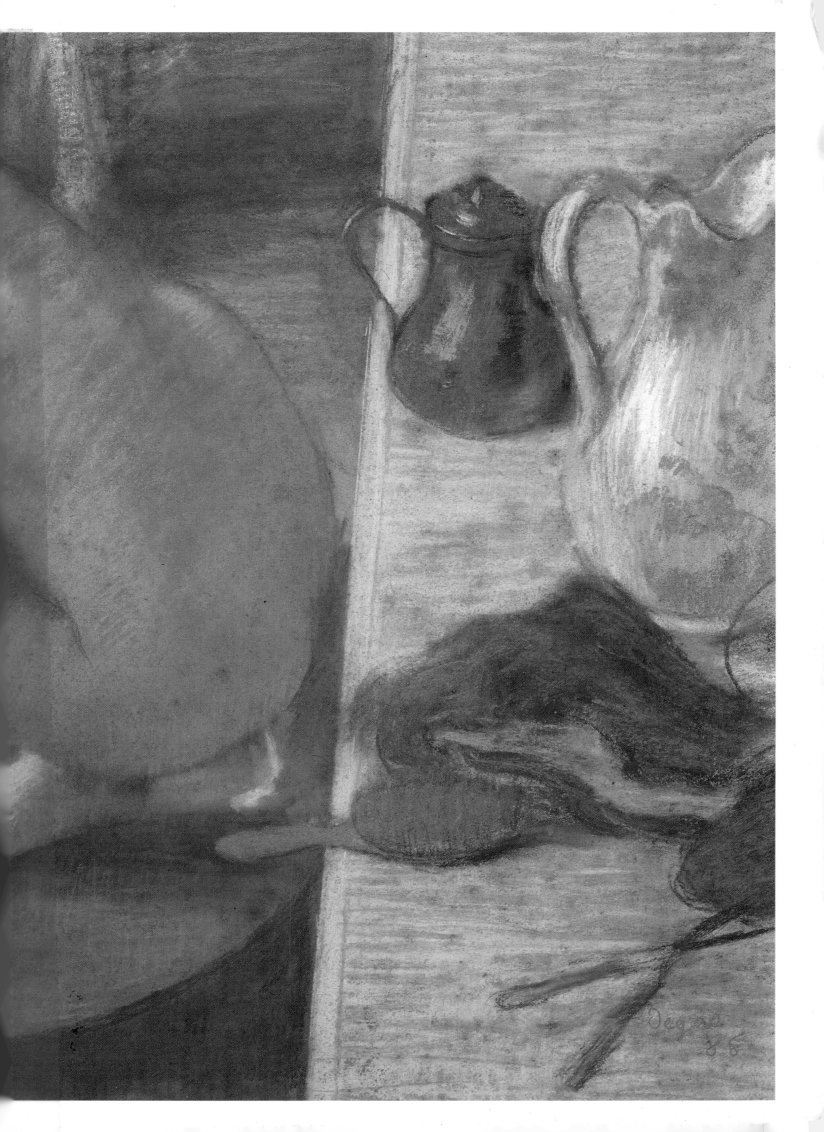

Edgar Degas: A Chronology

1834 Hilaire-Germain-Edgar de Gas is born on 19 July at 8, Rue Saint Georges in Paris, the first of five children. His father, Pierre Auguste-Hyacinthe de Gas, is the manager of a branch of a private bank belonging to Edgar's grandfather in Naples. His mother, Célestine Musson, is of Creole descent and comes from New Orleans.

1845 Degas goes to the Lycée Louis-le-Grand.

1853 Passes his Baccalauréat and matriculates in the university faculty of law. Visits Félix Barrias's studio. Copies Mantegna's *Crucifixion*.

1855 In April enrols at Ecole des Beaux-Arts in the painting and sculpture faculty.

1856 July: travels to Naples to visit relatives, and later continues to Rome.

1859 Returns to Paris. Works on portrait of the Bellelli family.

1860 Stays with the Valpinçons at Ménil-Hubert in Normandy. Degas is particularly interested in historical art.

1865 Exhibits *The Sufferings of the City of New Orleans* at the Salon.

1869 Paints portraits. Stays with Manet at Boulogne-sur-Mer and Saint-Valery-en-Caux. Does landscapes from memory and close studies of horses and jockeys.

1870 Ordered to the Garde Nationale artillery in the Franco-Prussian War, under the command of his old school friend Henri Rouart. Contracts an eye condition.

1871 During the Paris Commune he stays at Ménil-Hubert.

1872 Travels to London and on to New Orleans, where his relatives are

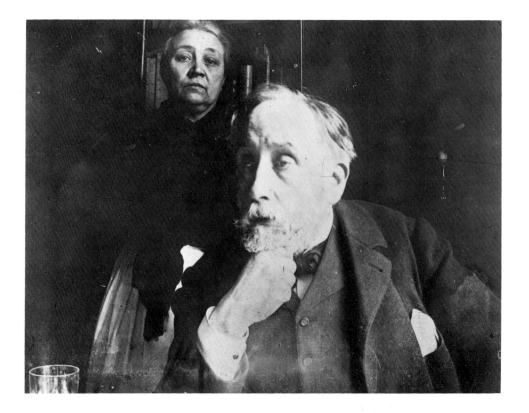

Degas at home with his housekeeper Zoé Closier, 1890–95

Degas, about 1855–60

Renoir and Mallarmé, 1895

Degas in his studio, about 1898

in the cotton trade. Does a number of portraits, among them *Portraits in a New Orleans Cotton Office.*

1873 With others, Degas founds the "Société anonyme" to organize independent, unjuried exhibitions.

1874 February: his father dies in Naples. Degas exhibits ten works at the first Impressionist exhibition, which opens on 15 April.

1876 30 March: The second "Société anonyme" exhibition opens, including 24 pictures by Degas. Edmond Duranty publishes "La Nouvelle Peinture", which contains a lengthy assessment of Degas. He works on monotypes and etchings.

1877 Degas shows 25 works in the third group exhibition.

1878 The *Cotton Office* is bought by the Musée des Beaux-Arts at Pau for 2000 francs, the first of his works to be hung in a museum. His pictures are exhibited in America for the first time.

1879 Fourth Impressionist exhibition. Along with oil and pastel work, Degas exhibits painted fans.

1880 The fifth independent show

opens on 1 April. Durand-Ruel buys work by Degas.

1881 Exhibits the sculpture of the little dancer at the sixth independent exhibition.

1882 First pictures of milliners and women ironing. Degas does not exhibit at the seventh independent show.

1883 Durand-Ruel exhibits Degas and other artists in London.

Degas in Bartholomé's garden, about 1908

1886 At the eighth independent exhibition, Degas shows a series of nudes. With Georges Seurat's *Grande Jatte* they are the sensation of the show.

1888 Writes sonnets that deal with subjects treated in his art: dance, horses, singers.

1892 Almost entirely abandons painting in oils. September: exhibition of landscapes at Durand-Ruel, the first of only two solo exhibitions in his lifetime.

1900 Shows two paintings and five pastels in the century exhibition in Paris.

1901 Almost totally blind, Degas can no longer work except in large formats and with broad strokes of chalk; he sometimes retouches earlier work.

1911 Second solo exhibition at the Fogg Art Museum.

1914 The Cammondo collection, containing numerous works by Degas, is given to the Louvre.

1917 27 September: Degas dies. He is buried in the family grave in Montmartre cemetery.

Bibliographical Note

Adhémar, Jean/Cachin, Françoise: Degas. Etchings, Lithographs, Monotypes. Paris 1973

Adriani, Götz: Edgar Degas. Pastelle. Öl-bilder. Zeichnungen. Cologne 1984

Cabanne, Pierre: Edgar Degas. Munich 1960

Graber, Hans: Edgar Degas. Nach eigenen und fremden Zeugnissen. Basle 1942

Herbert, Robert L.: Impressionismus: Paris – Gesellschaft und Kunst. Stuttgart/Zurich 1989

Lemoisne, Paul André: Degas et son œuvre (4 vols.). Paris 1946–49

Reff, Theodore: Degas. The Artist's Mind. New York 1970

Rewald, John: Degas Sculpture. London 1957

Schmid, Wilhelm (ed.): Wege zu Edgar Degas. Munich 1988

Sutton, Denys: Edgar Degas. Munich 1986

Valéry, Paul: Degas, danse, dessin. Paris 1938

Information on individual works is from the catalogue Edgar Degas, Paris/Ottawa/New York, 1988/89; Franco Russoli/Fiorella Minervino: L'opera completa di Degas, Milan, 1970; and The Notebooks of Edgar Degas (2 vols.), Oxford, 1976.

Photo credits

Paris, © Photo R.M.N.: pp. 6, 11, 16, 18, 19, 21, 25, 26, 28, 30, 36, 38, 40, 42, 43, 48, 54/55, 59, 70, 78, 79, 83, 92/93
Copenhagen, Ole Woldbye: p. 24
Peissenberg, Artothek: pp. 37, 47, 69
London, The Bridgeman Art Library: pp. 46, 81, 84
Paris, Photographie Archives Durand-Ruel: p. 58
London, reproduced by kind permission of the curators of the British Museum: p. 82
Paris, Bibliothèque Littéraire Jacques Doucet: p. 94
Paris, Bibliothèque Nationale: p. 95